Cecilia Jannella

"DUCCIO DI BUONINSEGNA"

SCALA/RIVERSIDE

CONTENTS

the SCALA
ARCHIVE, which specializes in large-format colour
transparencies of visual arts from all over the world.
Over 50,000 different subjects are accessible to users by
means of computerized systems which facilitate the rapid
completion of even the most complex iconographical
research.

© Copyright 1991 by SCALA, Istituto Fotografico
Editoriale, S.p.A., Antella (Florence)
Translation: Laura Molinaro Bailache
Editing: Karin Stephan
Layout: Fried Rosenstock and Ilaria Casalino
Photographs: SCALA (M. Falsini and M. Sarri) except
no. 12 (Kunstmuseum, Bern); nos. 18, 26, 49, 50
(National Gallery, London); nos. 27, 28, 43 (National
Gallery of Art, Washington); no. 42 (Frick Collection,
New York); nos. 47, 48 (Thyssen-Bornemisza
Collection, Lugano); no. 51 (Kimbell Art Museum, Fort
Worth/Texas); no. 98 (Szépmüveszéti Muzeum,
Budapest)
Produced by SCALA
Printed in Italy by Centrooffset
Siena 1991

An Outline of the Life and Works of Duccio

Considering the general scarcity of documents regarding the lives of Italian medieval painters, information concerning Duccio di Buoninsegna is unusually plentiful. This allows us not only to trace the more important stages of his artistic career but also reveals the restless temperament underlying the elegant dignity of his style. During the course of his lively existence the artist incurred a number of fines and debts on the basis of which we can make a fairly accurate estimation of his character and, although not occurring within a strictly professional context, these show him to be rebellious to any form of authority. The first of the frequent fines inflicted on him by the Commune of Siena was in 1280: the nature of the offence is not recorded but the hefty sum of one hundred lire suggests that it must have been serious. Encouraged and protected perhaps by his artistic renown, Duccio's hotheadedness frequently led him into trouble. In 1289 he refused to swear allegiance to the commander of the local militia, and in 1302 declined to take part in the war in Maremma, for which he was fined eighteen lire and ten soldi. On 22 December of the same year he was again fined, for an incident apparently connected with the practice of sorcery, since he was taken "before the magistrate for witchcraft in the district of Chamomillia". This accusation cannot have been very serious since he was fined the modest amount of five soldi. We know that in 1292 he owned a house in Camporegio near the Church of Sant'Antonio in Fonte Branda, which may have been the one in which he grew up since in 1229 it appears that a Buoninsegna, usually identified as the artist's father, was actually living in Camporegio. He also owned fields and vineyards in the country and in 1313 was joint owner of a house in the Stalloreggi quarter where he lived and had his workshop. However, the fines for non-payment of debts, which appear regularly in written sources, confirm a disorganized way of life and difficulties with managing money. Despite continual reprimands from the law-courts, showing his persistence in a disrespectful attitude especially towards public authority, Duccio was able to follow a brilliant career which progressed and reached its peak thanks to the same authorities that penalized him. His defects as a citizen were effectively overshadowed by his creative inspiration which, although still attached to the Byzantine world, was discovering new stylistic solutions that were to become the measuring stick for the most important local artists.

Duccio is first mentioned in 1278: a document of

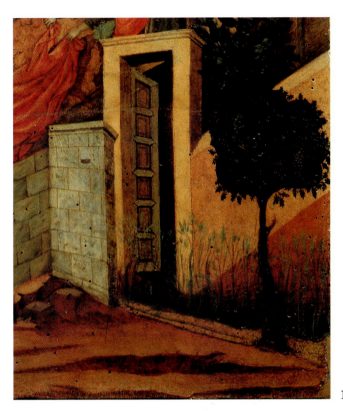

1

1. *Maestà (rear)*
The Entry into Jerusalem, detail
Siena, Museo dell'Opera del Duomo

the Commune of Siena records the payment of forty soldi to *Duccio pictori* for painting some of the wooden tablets which covered the account books of the *Biccherna* — the revenue office of the Commune. Duccio's probable date of birth has been calculated from this document. To receive payment in his own name the painter must have already reached the age of majority and therefore have been born about twenty years earlier, between 1255 and 1260. The designation *pictor* confirms not only his attainment of professional independence but also the beginning of an artistic style which was soon to develop the distinct character shown a few years later, in 1285, when Buoninsegna painted the *Rucellai Madonna* for the Church of Santa Maria Novella in Florence. Payments for jobs of the kind mentioned above, all *picturae librorum* of which unfortunately no trace remains, are registered for the years 1279, 1285, 1286, 1287, 1291, 1292, 1294 and 1295. These paintings were to represent only the badge of the administrator in office and it was not until later, halfway through the fourteenth century, that the iconography of the *Biccherna* was to include more elaborate elements with sacred and profane motifs.

We know nothing of Duccio's very early style, but an examination of a series of works attributed to him in the period immediately before the *Rucellai Madon-*

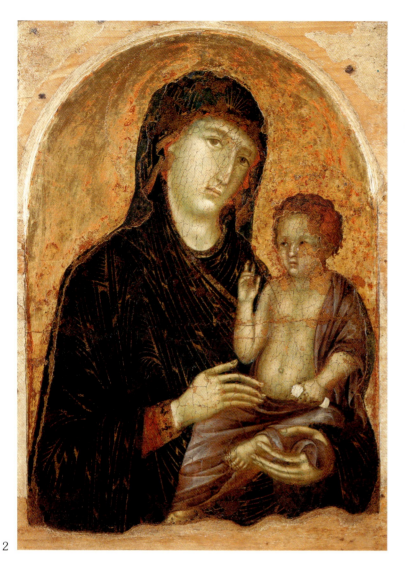

2. *Madonna and Child*
67x48 cm
Buonconvento, Museo d'Arte Sacra della Val d'Arbia

3. *Crevole Madonna*
89x60 cm
Siena, Museo dell'Opera del Duomo

na — also called the *Laudesi Madonna* — places him among the followers of the great Cimabue. Because of the strong formal affinities between the two painters apparent in these pictures, they have been subject to numerous disputes over authorship. The only ones attributable to his early period — around 1280 — and accepted by most art historians as the work of Duccio are the *Madonna* of Buonconvento and the *Crevole Madonna*.

The theory of Roberto Longhi, formed in 1948 and seconded at various times by other critics, that Duccio stayed in Assisi, appears to be the most plausible explanation for the controversial problem of his formation. From an accurate examination of the style of the early works and of the documents it would seem that between the end of the 1270's and the first half of the 1280's, when no written mention is made of Duccio's presence in Siena, he was part of Cimabue's following at the Upper Church of San Francesco at Assisi, where his hand can be detected in the frescoes in the transepts and the nave. In assuming Cimabue to be the probable link between Duccio and Florence, the Florentine commission of the *Laudesi Madonna* immediately afterwards finds a reasonable justification.

Traces of the period Duccio spent as a pupil of Cimabue can be seen in the round stained-glass window of the choir of Siena Cathedral, executed in 1288, the preparatory drawings of which have been rightly attributed to Duccio by Enzo Carli.

From the mid-thirteenth century Siena broadened its artistic horizons to welcome the innovating spirit of Frederic II and the refined tastes from beyond the Alps, marking a cultural transition towards new stylistic tendencies. Many factors contributed to transforming Siena into one of the most vital centres of artistic experimentation: the presence of the Pisano family, first Nicola then his son Giovanni, of Arnolfo di Cambio, of the goldsmith Guccio di Mannaia, and of enterprising local artists who did not hesitate to go to France to study the Gothic trends *in loco*. In this highly receptive environment the name of Buoninsegna caused increasing comment. In 1295 Duccio is mentioned as the only painter called upon to be a member of a special committee, formed by the masters of the Opera del Duomo, amongst whom was Giovanni Pisano, set up to decide where the new fountain, the Fonte d'Ovile, should be placed. As Ferdinando Bologna asserts: "in those days the various areas of artistic

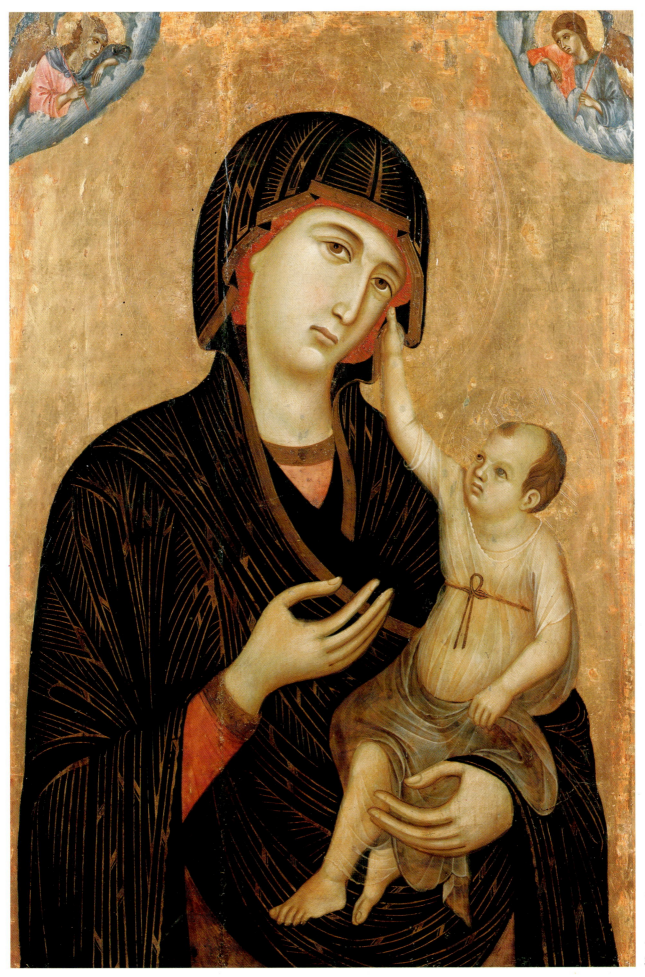

experience involved culture, technical training, operational ability, practical aims, structural and aesthetic requirements, all of equal importance and interchangeable on the level of an essential basic unity". This seems to be the case of Duccio who in undertaking to decorate the covers of the *Biccherne*, to supply the designs for the window in the Cathedral and to execute a work of such monumental importance as the *Maestà*, shows a proficiency which is versatile and skilled in the extreme.

His artistic production between the *Rucellai Madonna* and the *Maestà* for Siena Cathedral, placed on the main altar on 9 June 1311, consists of a group of works of now indisputed attribution: the *Madonna* of the Kunstmuseum in Bern, the *Madonna of the Franciscans* in the Pinacoteca in Siena, the *Madonna and Child* known as the *Stoclet Madonna*, previously in Brussels, the *Madonna and Child with Six Angels* in the National Gallery of Umbria, in Perugia, and the little *Triptych no. 566* in the National Gallery of London. A stylistic analysis reveals a progressive abandonment of the more conservative forms (rigid head and shoulders posture of Eastern tradition and light and shade treatment from Cimabue), giving place to innovating trends in painting: curving outlines, delicate colouring and intimacy of gesture.

The evident Gothicism of the *Maestà*, both in form and arrangement, and the absence of Duccio's name from Sienese records of the last years of the thirteenth century, could be evidence of a possible trip to Paris; however it appears that the *Duch de Siene* or the *Duch le lombart*, mentioned in the *Livre de la Taille* of Paris as resident in Rue des Prêcheurs, in the quarter of Saint-Eustache, was only someone with a similar name (thus the theory advanced by James Stubblebine did not find much support among art historians). A "maestà which he painted and a predella", executed for the Cappella dei Nove in the Palazzo Pubblico and for which on 4 December 1302 forty-eight soldi were paid to "maestro Duccio the painter as his salary", is unfortunately lost. Some critics have attempted to reconstruct it, seeing it as a work of great significance chiefly because of the collaborators involved. Many "workshop productions" follow earlier standards too far removed from the *Maestà* of 1311 and should therefore be connected with this previous

work. It was certainly one of the earliest examples of an altarpiece with a predella.

On the eve of the Battle of Montaperti, which was to result in the defeat of the Florentine troops on 4 September 1260, in front of the *Madonna with the Large Eyes* on the main altar of the Cathedral, Siena declared an "act of donation", in which it placed itself publicly under the protection of the Virgin. This gesture of loyalty formally sanctions the beginning of the intense cult of the Virgin which was to reach its peak in the extraordinary *Maestà* painted by Buoninsegna between 1308 and 1311. In its structural complexity, its size and its compositional excellence the painting marks the culminating point in the evolution of the altarpiece while the pictorial achievement conveys the city's intention: Mary, indisputed protagonist, rules over the community of the faithful.

Many theories have been advanced regarding authorship of the works of his last years, but the only painting in which the hand of Duccio can be detected is the *Polyptych no. 47* in the Pinacoteca of Siena.

3 August 1319 represents the *terminus ante quem* in determining when he died. On this date ser Raniero di Bernardo drew up the official deed in which the painter's seven children — Ambrogio, Andrea, Galgano, Tommè, Giorgio, Margherita and Francesco — who with his wife Taviana, outlived him, renounced their paternal inheritance. The document was legally registered on 16 October of the same year. Of the children, Galgano and Ambrogio appear to have taken up an artistic career (although this is not supported by any documentary evidence), as Duccio's nephew, son of his brother Bonaventura, the well-known Segna and father of Niccolò and Francesco, had already done.

It is not possible here to make an exhaustive study of the collaborators in the workshop; however it should be remembered that the new creative impulse carried on after Duccio's death. From the thirteenth-century 'Master of the Badia at Isola', to Ugolino di Nerio, the works of minor artists reveal clear traces of Duccio's style. This is reflected with faithful precision by the 'Master of Città di Castello' and the 'Master of Monte Oliveto', for example, but it also reappears in the more delicate contemplative interpretation of the young Simone Martini and of Pietro Lorenzetti.

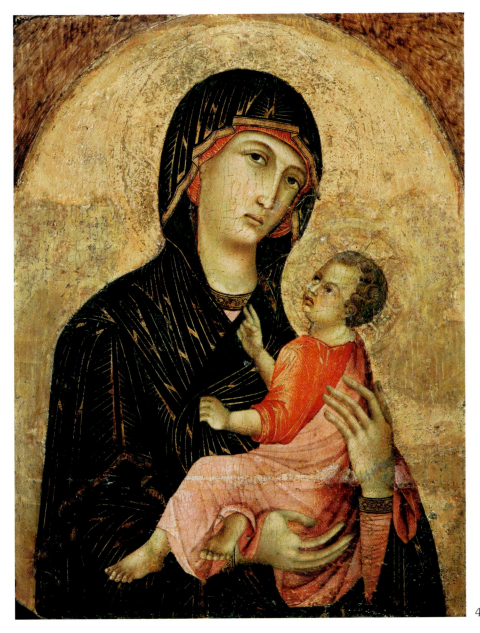

4

Duccio: "Not merely a Pupil, but practically the Creation of Cimabue"

Roberto Longhi's theory (*Giudizio sul Duecento*) that the style of Duccio was formed by Cimabue at Assisi has, with a few exceptions, been generally accepted and upheld insofar as it sheds light on both the obscure period of the painter's youth and the frequent connections between Florentine and Sienese art. The case of Duccio is an illustration of the cultural exchange between the two cities, which also affected other Sienese artists, evidently the more sensitive and alert, who were orientated towards Florence. The first actual meeting of the ways occured with Coppo di Marcovaldo, who had been taken prisoner after the

Battle of Montaperti and in 1261 bought his freedom by painting the *Madonna del Bordone* for the Church of the Servites. A faithful adherence to Cimabue's standards is apparent in miniatures of the choir-book 33-5 in the Opera del Duomo of Siena and of the gradual no. 1 of the Accademia Etrusca in Cortona, in the anonymous author of the *Crucifix* of San Gimignano, the well-known Vigoroso from Siena, and in the Master of the *St Peter Altarpiece* in the Pinacoteca of Siena. In comparison with these, the significance of the almost contemporary work of Duccio stands out for its effortless individual interpretation of the careful-

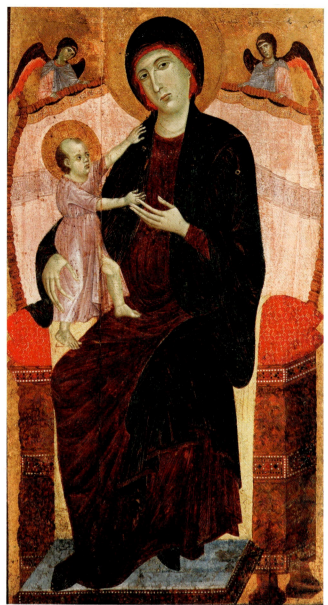

5

5. *Gualino Madonna*
157x86 cm
Turin, Galleria Sabauda

6. *Cimabue and Duccio*
Madonna and Child
68x47 cm
Castelfiorentino, Church of Santa Verdiana

ly studied lesson of the master. On the basis of penetrating observations by Longhi and Carlo Volpi, Ferdinando Bologna has tackled the problem of the formation of Duccio's style more than once, and has clearly outlined the development of the master-pupil relationship. This was established very early on "even earlier than 1278-79", when the first scaffolding for the frescoes had already been erected in the Upper Church of San Francesco, and it ended during the time of closest collaboration, around 1283-84 "when work had got as far as the vault of the Doctors". These are the most likely stages of their association: the *Angel* on the splay of the big window of the north transept in the Upper Church at Assisi, the *Madonna* in the Church of the Servites in Bologna, the *Madonna Gualino* in the Galleria Sabauda in Turin, the *Madonna* of Castelfiorentino, the *Crucifix* in the Odescalchi Collection, the *Madonna* in the Museo d'Arte Sacra of the Val d'Arbia in Buonconvento, the *Crevole Madonna* in the Museo dell'Opera del Duomo in Siena, the *Expulsion of the Forefathers* and the *Crucifixion* in the third bay of the south wall of the Franciscan Basilica, two of the *Winged Genii* which occupy the four corners of the vault of the Doctors in Assisi. Executed in a time-span of little more than five years, the paintings show strong stylistic affinities. In some cases (the *Madonna* in Bologna and the *Madonna* in Castelfiorentino) the painters seem to have achieved a real joint effort: the earlier style of the conception of these paintings suggests that the plan was Cimabue's, while the luminous treatment of colour implies that Duccio executed the work. The very fine *Odescalchi Crucifix* has also been considered the result of team-work and the iconographical motif portraying *Christus triumphans*, suggests an early date. The *Blessing Christ* of a private collection in Lugano has recently been recognized by Bologna as the original top piece of the Crucifix (now missing, together with the boards of the horizontal arms). For its "high quality and poetical tendency" the *Angel* of the large window resembles the *Gualino Madonna*, which is also very similar to the Bologna altarpiece, and together they anticipate the skill Duccio was to show in modifying the traits of his teacher, softening the over-harsh contrasts of line and colour. This is immediately apparent in the *Madonna* of Buonconvento and the *Crevole Madonna*, unanimously considered the earliest works attributable to Duccio. The basic approach of the two paintings is of evident Byzantine tradition: the elegant stylization of the hands, the typical downward curving nose, the red *maphórion* under Mary's veil, the dark drapery animated by shining gilded lines. New details appear, to a lesser extent in the Buonconvento *Madonna* and repeated with greater confidence in the Crevole painting, such as the subtle play of light on the Virgin's face, over her chin and cheeks, and a clear attempt at plasti-

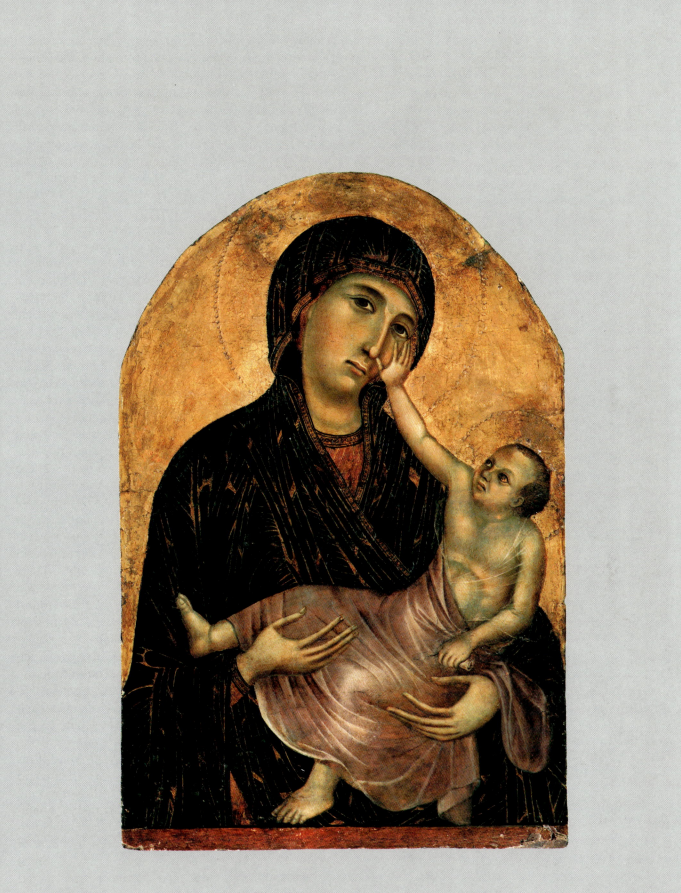

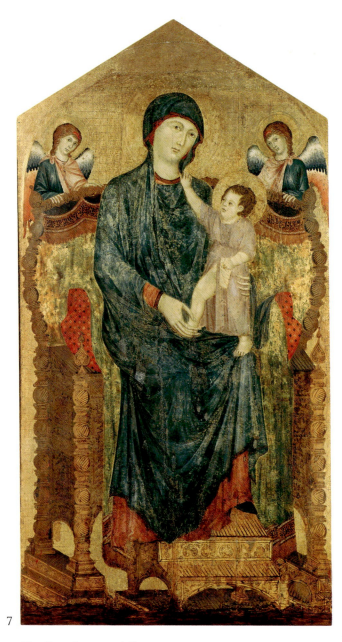

7

7. Cimabue and Duccio
Maestà (before restoration)
218x118 cm
Bologna, Church of the Servites

8. Rucellai Madonna
450x290 cm
Florence, Uffizi

cism in the folds of the garment around the face.

The more carefully considered compositon of the *Crevole Madonna* shows a faint but decided French influence: the elegant forms of the angels in the upper corners, the veiled transparency of the Child's garment, held up by a curious knotted cord, and most of all, the intimate gesture of the Infant Jesus, held in a tender embrace. With regard to the anonymous 'Master of the Badia at Isola' it is worth recording Bologna's comment that in all probability "having been formed by Duccio very early on, he was at the beginning in such close relations with the master as to lend credibility to the opinion that Duccio's hand can be detected in some of his early works". As an example of this, Bologna cites "the very beautiful Madonna no. 593 in the Pinacoteca of Siena whose face is really so close to Duccio's *Crevole Madonna* that it could easily be attributed to him and dated to that period".

The paintings of Buonconvento and Crevole show clear similarities with the Assisi fresco of the *Expulsion of the Forefathers* where, although his characteristic style is perhaps less evident, the same melancholy spirit reigns and the same technique and brushwork are used. Greater formal maturity and feeling for the Gothic style appear in the scene of the *Crucifixion*, executed shortly afterwards. Although in a poor state of preservation, an attempt at greater plasticism is visible, almost a forerunner of the spacious volumes of Giotto, although not fully realized because of the ties still binding the young Duccio to Byzantine art. If, on the one hand, the group of mourning angels, in particular the left one, echoes the typical features of the "Madonnas" examined up till now, on the other, it clearly anticipates the *Rucellai Madonna*. Duccio's presence at Assisi appears to end with his work on the vault of the Doctors, where two corner putti show strong similarities with the Child of the *Madonna* of Castelfiorentino and that of the *Crevole Madonna*, and in comparison reveal Duccio's progress as an artist. But by then, on the eve of 1285, the proof of his artistic maturity was soon to appear in the outstanding Florentine altarpiece.

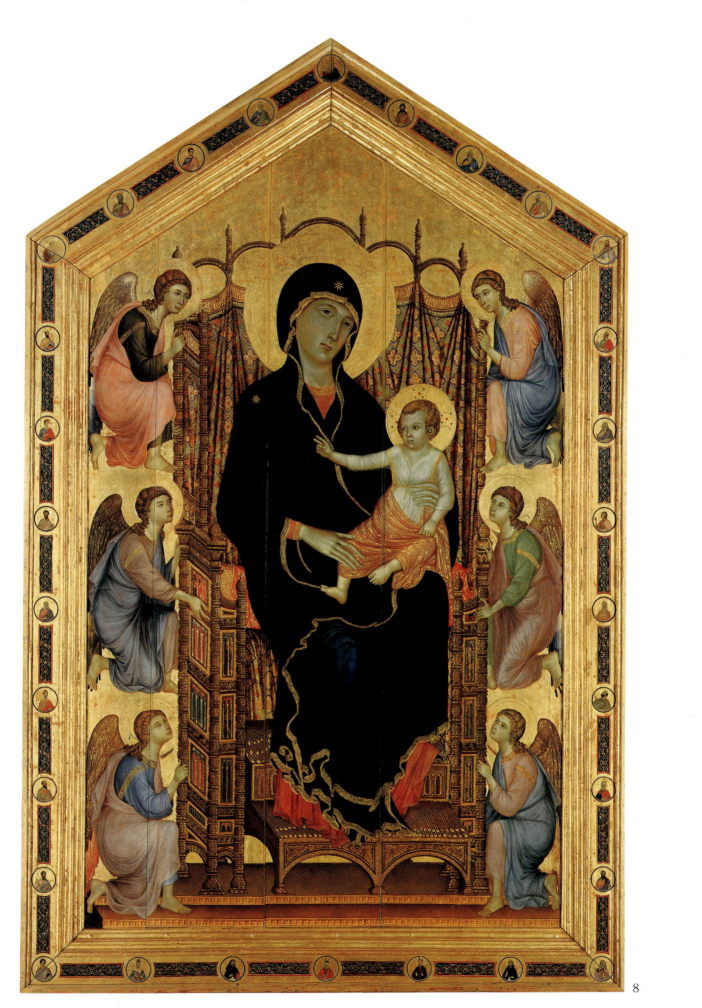

The Rucellai Madonna

The picture's name derives from the Rucellai Chapel of Santa Maria Novella where it remained, after being moved to several different places inside the church, from 1591 to 1937, the year of the Giotto exhibition. It was then transferred to the Uffizi. On 15 April 1285 the Confraternity of the Laudesi of the Church of Santa Maria Novella commissioned *Duccio quondam Boninsegne pictori de Senis* to paint a *tabulam magnam... ad honorem beate et gloriose Virginis Marie*. Although the employment contract was published at the end of the eighteenth century, it was a long time before the document was correctly associated with the *Rucellai Madonna*, which was then assigned to Duccio. The painting has been the subject of much controversy among critics. In the fifteenth century it was thought to be the work of Cimabue, and this attribution, supported by Vasari, was accepted until the beginning of present century. The design of the frame decorated with roundels, the three pairs of angels flanking the throne and the sweeping gesture of the Child's blessing hand, show undeniable similarities to Cimabue's *Maestà*, now in the Louvre but at that time in the Church of San Francesco in Pisa. This may have been the inspiration of Duccio; Giorgio Vasari, in his *Lives* (not always completely reliable), documents a not improbable sojourn in Pisa. Another detail of Florentine origin is the punching on some of the haloes, decorated with relief granulation, an engraving technique not practised in Siena, where incising the surface with a chisel was preferred. The elements from Cimabue are enriched with delicate Gothic overtones, unknown at that time, but which were to become a permanent feature of Sienese art. The brilliance of colour, the curving outlines and the sinuous movement of the gilded edging of Mary's cloak are all new. The entire structure of the throne reflects the influence from beyond the Alps: the panels are slender mullioned windows, the foot-rest is supported by a light double arch, the back is crowned with delicate arching and little pinnacles.

The iconographical interpretation is also new in that the angels holding up the throne no longer form the crowning part of a solemn and magnificent background but are all looking towards the Virgin in attitudes of intense emotional participation. The connection with the 1285 contract is borne out by the painted frame that fulfils a specific iconographical purpose in accordance with the intentions of the Confraternity of the Laudesi. This was founded within the Dominican order, around 1244-45, with the object of fighting heresy by means of an intensive preaching programme. In the medallion placed at the top is the image of Christ. On his left are twelve figures, mostly

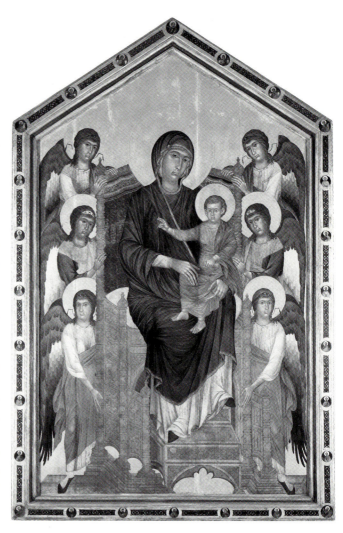

9

9. Cimabue
Maestà
Paris, Louvre

10. *Rucellai Madonna*, detail
Florence, Uffizi

prophets and patriarchs, among whom are: John the Baptist immediately next to the Redeemer, King David crowned and with the psalms, the young Daniel holding a roll. On the right of the Virgin, the Apostles, to whom the Child is turning to give his blessing, represent the New Testament. Peter and John the Evangelist are the first of the saints, many of whom are complete with books and scrolls that refer to the Gospel and in a more general sense underline the importance of preaching. The roundels in the lower section, more easily visible to the faithful, contain images of the saints to whom the Laudesi and the Dominicans were particularly devoted. In the centre is St Augustine of Hippo, whose rule guided the Dominican

10

friars. On the left are Catherine of Alexandria and Dominic. On the right is Zenobius, early medieval bishop and patron of the city, accompanied by Peter the Martyr, the then recently canonized founder of the Confraternity. The significance of the frame and the medallions is therefore not solely ornamental but conveys the commissioners' desire for self-proclamation: the Dominican brotherhood was to be visualized as a lay group championing the cult of the Virgin.

From the Rucellai Madonna to the Maestà

The Cathedral Window

Between 1285 and 1308, the year the Sienese *Maestà* was commissioned, documented information exists only on the stained-glass window in Siena Cathedral. The large "oculus" on the wall of the apse is divided into nine compartments, of which five form a cross, while the other four occupy the remaining sectors. On the vertical arm is the story of the Virgin with the *Coronation*, the *Assumption* and the *Burial*. On the horizontal arm, from the left, are the patron saints Bartholomew, Ansano, Crescenzio and Savino. In the corner compartments are the four Evangelists with their names and symbols: in the top left St John and in the top right St Matthew; below are St Luke and St Mark. Nothing is known about the identity of the master glazier who undertook the job. However, on the basis of Carli's thorough research it may be safely asserted that it was Duccio who made the preparatory drawings. In September 1287 the Commune of Siena entrusted the administrator of the Opera del Duomo with the task of arranging for the execution of a stained-glass window for the *fenestra rotunda magna que est post altare Beate Marie Virginis Maioris Ecclesiae*, and undertook to supply the necessary money for expenses. This agreement was evidently not kept because in May of the following year the Commune threatened to fine the camerlengo, or papal treasurer, and the administrators of the *Biccherna* if they did not reimburse the workman with the money for the purchase of the glass. The debt was then paid in two instalments of 100 and 25 lire, to "frate Magio". The presence of St Bartholomew, Siena's ancient patron saint, bears out the early dating since, as the *Maestà* of 1308-11 shows, he was later substituted by St Victor. At that particular moment in history, as Carli has correctly deduced, the only Sienese painter able to perform such an exacting task, and whose artistic ability had already been proved, was Duccio. A stylistic analysis further supports this conclusion. Although the work shows marked traces of Cimabue, apparent in the *Burial* scene and the figures of the Evangelists, it is exemplary in that it anticipates some typical compositional solutions of the *Maestà*. The angels in the *Coronation of the Virgin*, resting lightly on the back of the throne, and the solid architectural structure of the latter, assay a new conception of space where the rigidity of the contours, although confined within the lead edgings, is softened by subtle upward movements. The angels' wings extending beyond the frame of the *Assumption* break up the geometrical severity both of the mandorla enclosing Mary and of the background decorated with insets, and lend a rhythmic energy which adapts well to the overall proportions. The solid polychrome sarcophagus in the foreground of the *Burial* scene, and the crowded gathering of figures with haloes reveal an austere monumentality to be faithfully echoed later on in the section of the *Maestà* dedicated to the same subject. They also clearly reflect Cimabue's style. But perfect harmony between the window and the *Maestà* was reached in 1311 when the completed altarpiece glowed beneath the rays of the coloured glass, and the iconographical project of the glorification of the Virgin was magnificently realized.

The tiny *Triptych* belonging to the Fogg Museum in America and attributed to Buoninsegna by B. Rowland, appears to date from around 1285-90. The painting is in very poor condition, rendering impossible an exact interpretation and correct attribution. The most recent critics have therefore ascribed it more generally to Duccio's immediate circle. Bologna, in affirming its masterliness, cautiously suggests that Duccio executed the central panel.

11. Stained-glass window
700 cm (diameter)
Siena, Cathedral

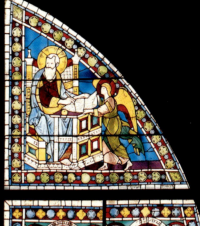

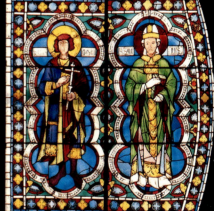
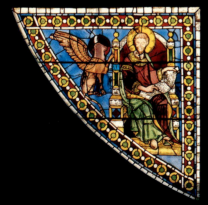

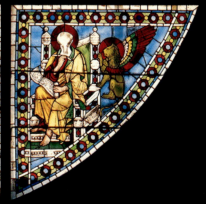

The "Small" Madonnas

When examining the *Madonna* of Bern and the *Madonna of the Franciscans*, Buoninsegna's extraordinary versatility must again be stressed. A feeling of uncertainty must arise when placing these small paintings (respectively 31.5 x 22.5 cm and 23.5 x 16 cm) side by side with works of such impressive grandeur as the *Rucellai Madonna* and the Cathedral window, so different in size and structural organization. However, a careful analysis of the two paintings leaves no room for doubt as to authorship. The self-confident ease Duccio reveals, in a type of pictorial art which has almost become the miniature, leads us to assume that a series of works now unfortunately all lost were of similarly high quality. An examination of the covers of the *Biccherna* account books, decorated by Duccio at various intervals from 1278, would have thrown light on the subject. These little paintings, so close in size to the *Madonnas* in question, would certainly have been a further proof of the skill as a miniaturist which stands out in these last two works.

A feeling of tenderness permeates the radiant *Madonna* of Bern, where the Virgin and Child are portrayed in a loving embrace. The gesture of intimate affection is taken from Byzantine iconography, from the motif of the *Glykophiloùsa*, in which Mary, with a presentiment of the sad future, clasps the Infant Jesus urgently to her breast. A closer reference can be seen in the *Madonna* in Bologna on which Duccio worked as an assistant of Cimabue, but its size and the barely indicated gesture greatly reduce the sense of intimate tenderness. The typology of the throne, decorated with Cosmati-like inlays and already experimented in several variations in the window of the apse, follows the lines of Gothic architecture, while the characteristic curling edge of Mary's dress evens out into a smooth gilt border.

The *Madonna of the Franciscans* shows greater structural articulation, and was probably part of a diptych or triptych intended for private worship, perhaps of a small group of Friars Minor. Iconographically it follows the "Madonna of Mercy" type: while looking towards the spectator the Virgin holds back the edge of her robe the better to receive and protect the three kneeling friars, for whom the Child's blessing is intended. This elaborate intermingling of echoes from Cimabue and Byzantine art, with the added softness of Duccio's personal touch, includes elements of the new artistic language from beyond the Alps. The tiny square panels of the backcloth, an innovation substituting the usual gold ground, are of clear French derivation, similar solutions appearing in the miniatures of the St Louis psalter and of the evangelistary in Sainte-Chapelle. Thus, the measured breadth of

contour, the sinuous curving of the robe's hem and the smooth masses of colour form part of a wider spatial dimension, where the Gothic predilection for linearity and flowing outlines reaches its maximum expression. The features of the supplicating friars and the throne, a simple wooden seat placed obliquely to create an effect of perspective, reflect the teaching of Cimabue. The unusual posture of the Child's legs belongs entirely to Duccio, however, who repeats the gestures of the early *Madonna* of Buonconvento and the *Laudesi Madonna*.

A *Madonna and Child*, better known as the *Stoclet Madonna* (present whereabouts unknown), has been assigned to the last years of the thirteenth century. Because of its size (27 x 21 cm) and the new approach to space, it fits into the art of Duccio well at this particular moment.

12. *Maestà*
31.5x22.5 cm
Bern, Kunstmuseum

13, 14. *Madonna of the Franciscans, and detail*
23.5x16 cm
Siena, Pinacoteca

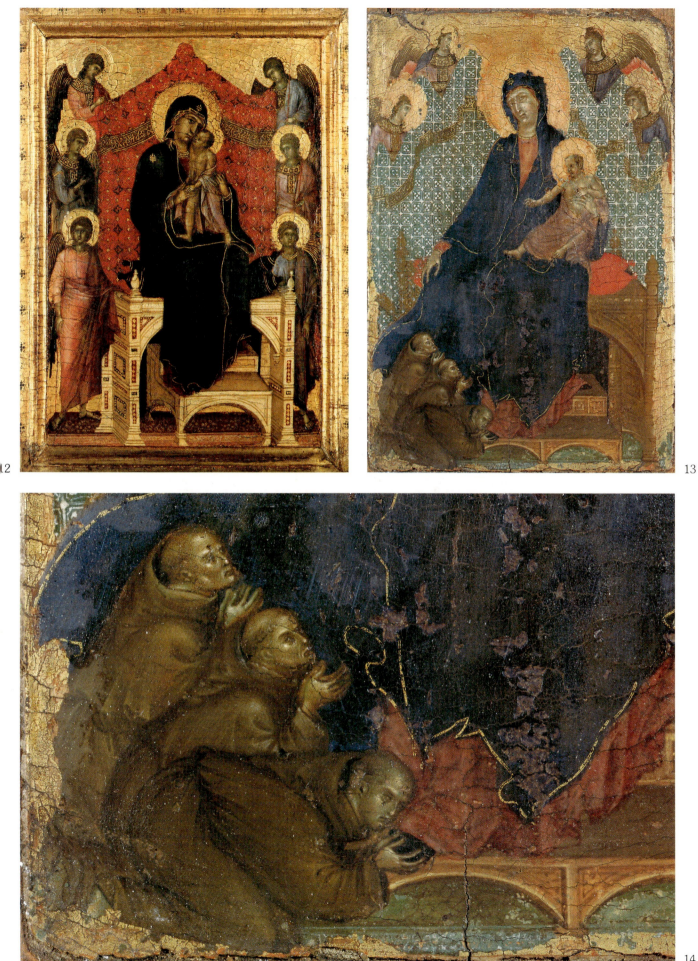

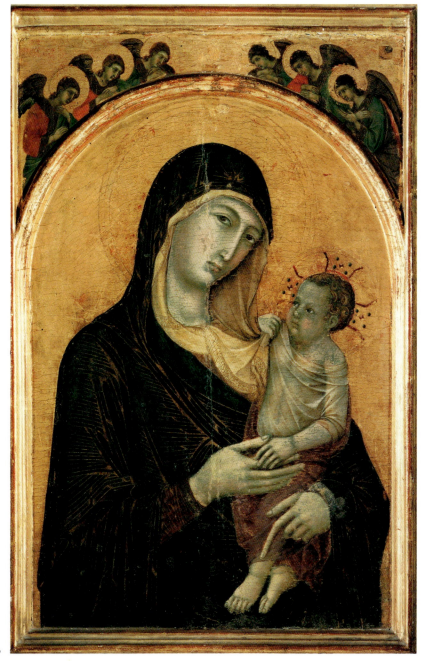

15

The Perugia Madonna

This painting, now in the local National Gallery, was kept perhaps *ab antiquo* up until 1863 in the monastery of San Domenico in Perugia, hung above the sacresty door or in the "Winter Choir". It was ascribed to Duccio in 1911 by Curt Weigelt and subsequent restoration revealed it to be the central panel of a dismantled polyptych. The formal stylistic elements of the traditional half-length portrait of the Madonna and Child develop into the portrayal of a solid mother and son relationship, showing a greater naturalness of gesture. Remarkable spontaneity is shown in the movement of the Child who is sitting on his mother's curved arm (a position shared by the *Stoclet Madonna*), clutching the soft folds of her veil. This detail in dress is of importance since it takes the place of the red Byzantine *maphórion*, evidently considered old-fashioned by the painter. The Virgin's gesture, showing the Child's hand and pointing to his feet, is also significant: it seems to allude to the future Passion of Christ. The original splendour of the painting is marred by its poor state of preservation, but although of high pictorial value it had no influence on local artistic production.

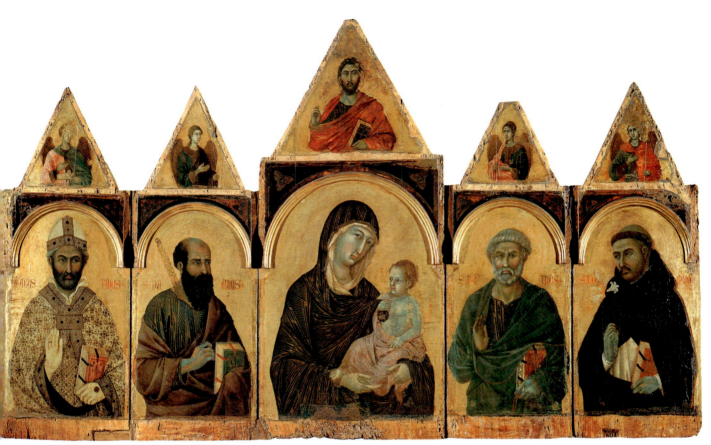

15. *Madonna and Child with Six Angels*
97x63 cm
Perugia, Galleria Nazionale dell'Umbria

16, 17. *Polyptych no. 28, and detail*
128x234 cm
Siena, Pinacoteca

Carli ascribes "definite Duccio authorship" to the Madonna of the *Polyptych no. 28* in the Pinacoteca of Siena. The whole work is assigned to the production of the workshop (perhaps partly because of its very bad condition) since it reveals a considerable amount of help, valuable but extensive, in the side panels and the pinnacles.

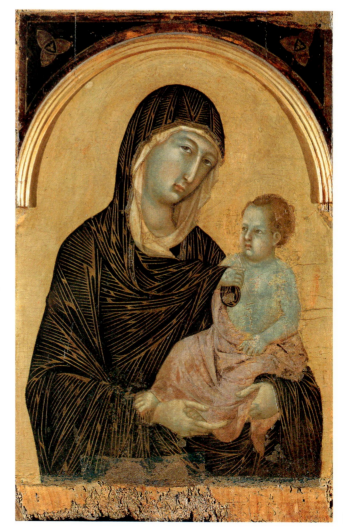

16

17

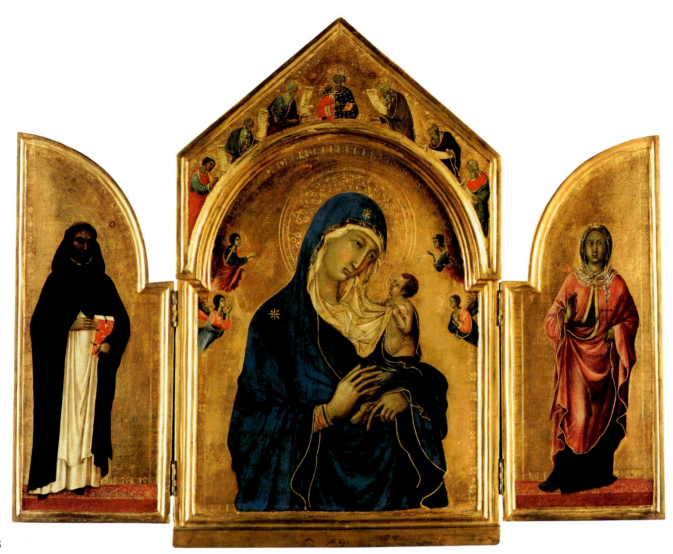

18

The London Triptych

This work, in the National Gallery in London, is a portable altarpiece of medium size (61.5 x 78 cm), consisting of three panels. On the sides, to the left and right respectively, are saints Dominic and Agnes: the latter was for a long time thought to be the very rare St Aurea until Cesare Brandi gave her back her true identity on the basis of the symbol of the double cross. On the central panel is the Virgin and Child with four angels. The upper section shows seven prophets, identified by the Bible verses contained in their scrolls; from the left they are: Daniel, Moses, Isaiah, David (in a perfect central position and distinguished by his name and crown), Abraham, Jacob and Jeremiah. Opinions vary as to the dating of the triptych, but it is generally agreed to be by Duccio. The overall arrangement of the central piece belongs to the same stylistic phase as the *Stoclet Madonna*, where the figure of the Child (painted very small according to oriental cus-

tom) and the slight twist of Mary's body to allow for the wide gesture of her outspread arm, are similar. On the other hand, the obvious taste for decorativeness and the rhythmic linearity of contour, displaying a wholly Gothic tendency, suggest a much later date, some years after the *Maestà*. Owing to its perfect state of preservation it is still possible to appreciate the glowing tints of the drapery, with its inevitable gilded edges, and the delicate transparency of St Agnes's veil and the Child's little garment.

18. Triptych
61.5x78 cm
London, National Gallery

The Maestà — the Masterpiece

The employment contract concerning the *Maestà*, drawn up on 4 October 1308 between the Cathedral workman Jacopo, son of the late Giliberto Mariscotti, and Duccio di Buoninsegna, is preserved in the State Archives of Siena. The *carta di pacti fatti col maestro Duccio per cagione della tavola Sancte Marie* contains a set of clauses which, rather than giving practical advice regarding the execution of the work, lay down certain rules of conduct: the painting should be entirely by the artist's own hand (*laborabit suis manibus*), he must undertake the task with all the skill and ingenuity that God has granted him (*pingere et facere dictam tabulam quam melius poterit et sciverit et Dominus sibi largietur*), and must work uninterruptedly accepting no other jobs until the great picture should be completed. As further security he swore on the Gospel to abide by the agreement *bona fide, sine fraude*. It seems that Duccio's restlessness, mentioned earlier on, had to be curbed by a promise in writing. The daily wage was sixteen soldi, a substantial sum considering the vastness of the undertaking which would require years of work and large quantities of materials (preparation of the panels, colours, gold), for the cost of which Duccio was not liable. No expense was to be spared. Agnolo di Tura del Grasso, a chronicler of the mid-fourteenth century, records that "it was the most beautiful picture ever seen and made, and cost more than three thousand gold florins". The figure was certainly exaggerated but was nevertheless very large, one of the highest paid to an artist. About three years later the *Maestà* was ready to be shown to the worshipping crowds of the faithful. An unknown contemporary writer gives an account of what happened in Siena on 9 June 1311, which for the occasion was declared a public holiday: "and on the day that (it) was carried to the Cathedral, the shops were closed and the Bishop ordered a great and devout company of priests and brothers with a solemn procession, accompanied by the Signori of the Nine and all the officials of the Commune, and all the people, and in order all the most distinguished were close behind the picture with lighted candles in their hands; and the women and children were following with great devotion: and they all accompanied the picture as far as the Cathedral, going round the Campo in procession, and according to custom, the bells rang in glory and in veneration of such a noble picture as this, ... and all that day was spent in worship and alms-giving to the poor, praying to the Mother of God, our protectress, to defend us by her infinite mercy from all adversity, and to guard us against the hand of traitors and enemies of Siena".

As already stated, the sacred picture takes on a new meaning: side by side with its religious significance (publicly decreed in 1260 when the Virgin was elected supreme protectress) is the political aspect, referring to specific local events. It is no accident that the saints surrounding Mary include the city's four patrons (from the left Ansano, Savino, Crescenzio and Victor), easily recognisable by their names in writing and depicted, significantly, on their knees in supplication: if the Virgin is the intercessor between Christ and humanity, it is Siena who is praying and the patron saints intercede for her. The words painted on the step of the throne clearly confirm everything that the iconography is meant to convey: *Mater Sancta Dei sis causa Senis requiei sis Ducio vita te quia pinxit ita* (O Holy Mother of God, grant peace to Siena and life to Duccio who has painted you thus). The focal point is the urban reality, a community united only in a very general sense, and extremely varied in its social make-up with sharply divided secular and ecclesiastical powers. The members of the local government ("the Signori of the Nine") and their officials also took part in the procession, along with the community of the faithful and the clergy. The event therefore goes beyond a solely religious context and involves the entire populace. The Commune met part of the expenses for the celebrations, such as paying the "players of trumpets, bagpipes and castanets" who accompanied the long procession with their music. This seems to pave the way for when, a few years later in 1315, Simone Martini's *Maestà* fresco was painted not in a church (the usual place for veneration), but in the Town Hall, in the Sala del Mappamondo, where the Council of the Nine carried out its governmental duties. In this profane setting the sacred element merges with the earthly dimension, becoming the symbol of the city.

Originally Duccio's *Maestà*, painted on both sides, was complex in its structural organization. The central panel, showing on the front side the *Madonna and Child Enthroned with Angels and Saints* and on the back side, in twenty-six compartments, *Stories of the Passion of Christ*, had a predella with episodes from the *Early Life of Christ* alternating with six prophets on the front, and scenes from *His Public Life* on the back. It was surmounted by panels (on the front, the *Last Days of the Virgin*, on the back, stories of *Christ after the Resurrection*) that culminated in pinnacles representing angels. An inventory of 1423 shows that the painting had been provided with a baldachin with three small tabernacles and carved angels; when set in motion by a special mechanism the latter held out to the priest the necessities for celebrating Mass: "a panel painted all over with figures of Our Lady and numerous Saints, with the three little vaults at the top in four

MAESTÀ, RECTO

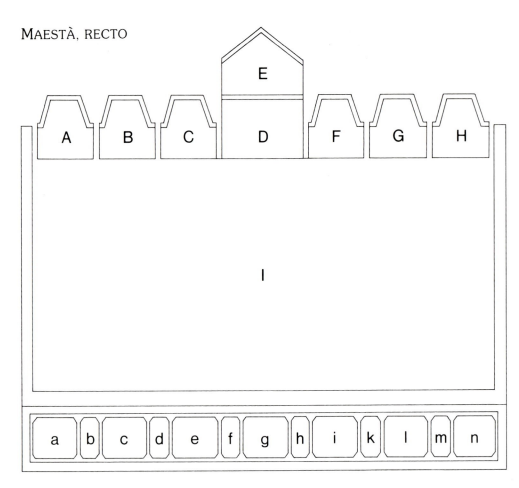

19. Hypothetical
reconstruction of the
Maestà

Front crowning section
A Announcement of Death
to the Virgin
B Parting from St John
C Parting from the Apostles
D Assumption of the Virgin?
E Coronation of the Virgin
F Death
G Funeral
H Burial

I Madonna and Child
Enthroned with Angels
and Saints

Front predella
a Annunciation
b Isaiah
c Nativity
d Ezekiel
e Adoration of the Magi
f Solomon
g Presentation in the
Temple
h Malachi
i Slaughter of the Innocents
k Jeremiah
l Flight into Egypt
m Hosea
n Disputation with the
Doctors

MAESTÀ, VERSO

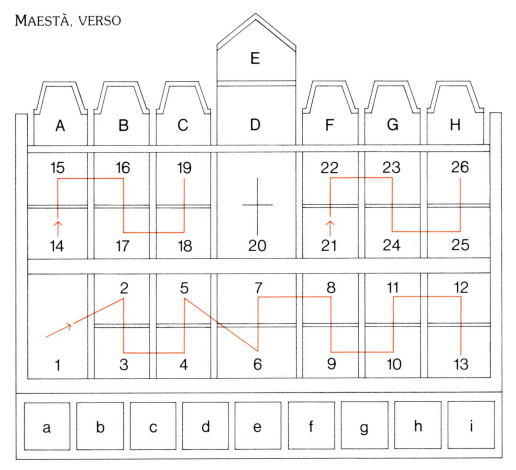

Back crowning section
A Appearance behind
Locked Doors
B Doubting Thomas
C Appearance on Lake
Tiberias
D Ascension?
E Christ in Glory?
F Appearance on the
Mountain in Galilee
G Appearance While the
Apostels are at Table
H Pentecost

Central panel
1 Entry into Jerusalem
2 Washing of the Feet
3 Last Supper
4 Christ Taking Leave of
the Apostles
5 Pact of Judas
6 Agony in the Garden
7 Christ Taken Prisoner
8 Christ Before Annas
9 Peter Denying Jesus
10 Christ Before Caiaphas
11 Christ Mocked
12 Christ Accused by the
Pharisees
13 Pilate's First Interrogation
of Christ
14 Christ Before Herod
15 Christ Before Pilate
Again
16 Flagellation

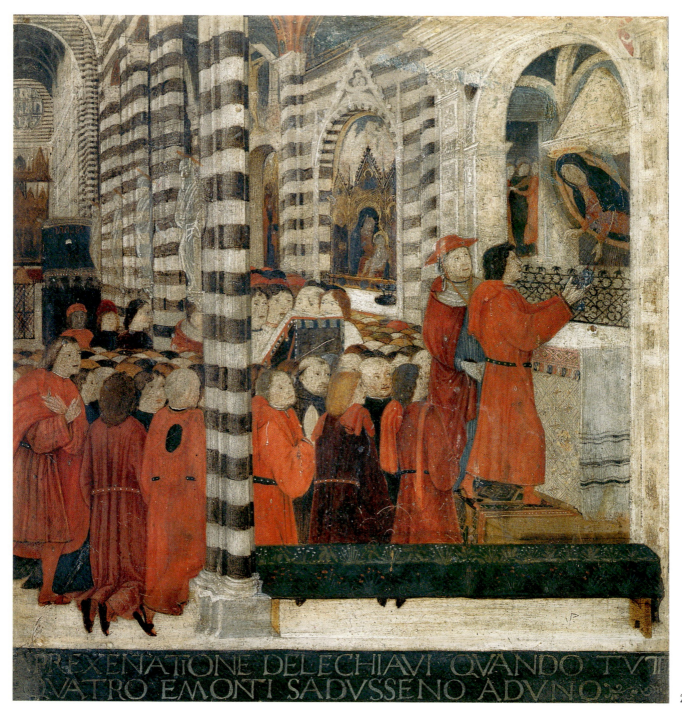

20

20. Sienese painter of the second half of the 15th century
Biccherna tablet of 1482 depicting the offering of the keys of the city to the Virgin Mary in the Cathedral
Siena, State Archives

iron borders, and three small tabernacles with tiny golden angels in relief inside, coming down to celebrate the holy mass with the eucharist and vessels and hand cloths". A small picture in the tax office, of 1482, representing the offering of the city keys to the Madonna, shows the Cathedral interior where part of the *Maestà* is visible, painted as described in the inventory; above, on the left, the round window can also be seen.

The picture remained on the high altar until 1505, when owing to repairs it was placed beside the altar of St Sebastian, now the altar of the Crucifixion. Because of this move Vasari, perhaps rather inattentive in spite of the effort he claimed to have made, did not manage to see it in 1568: "I tried to discover where the picture now is, but for all my diligence I was never able to find it". On 1 August 1771 the altarpiece was dismembered. In order to separate the two painted surfaces it was roughly sawn into seven parts and split up in correspondence with the single panels, sparing neither the predella nor the crowning section. The poplar boards, glued together and tightened with nails, proved very hard to cut away and the result was ruinous; the figures of the Virgin and Child on the front were damaged by the blade striking through. The panels were carelessly deposited "in some mezzanines on the third floor of the house of the Opera del Duomo ... in a low, dark place" and were then reassembled and placed in the Cathedral again, in the chapels of Sant'Ansano and the Sacrament. The scholar Guglielmo Della Valle, protesting in his *Lettere Sanesi* of 1785 against the havoc wrought, observes with good reason that "the picture has suffered greatly both from the mutilation to which it was subjected and from the various moves it underwent". As a consequence of all this, not only was the carpentry destroyed (frames, pinnacles, dividing elements) but several compartments of the predella and crowning section were lost — eight of these turned up in foreign museums and collections. In 1878 those parts still in Siena were brought together again in the Museum of the Opera del Duomo, where they have remained to the present day.

This division of the altarpiece in the eighteenth century has made it difficult to determine the exact structure of the original work and the sequence of the sections in the predella and crowning parts. In any case, the loss of four panels which, in pairs, made up the centre of the crowning section means that any reconstruction is incomplete. It is thought that these panels were: on the front, the *Assumption* and *Coronation of the Virgin*; on the back, the *Ascension* and *Christ in Glory*. In the opinion of Alessandro Conti, Duccio's hand can be recognized in a *Coronation of the Virgin* in the Szépmüveszéti Muzeum in Budapest. He believes that this was the central panel of the crowning section. The fifteenth-century *Commentary* by Lorenzo Ghiberti, would seem to support the suggestion that the *Maestà* included this scene: "and on the front the Coronation of Our Lady and on the back the New Testament". Every trace has been lost of the first scene on the back of the predella which most probably represented a *Baptism of Christ*. Furthermore, if we accept Miklòs Boskovits' suggestion that there were two painted panels on the shorter side of the predella, it would seem that the altarpiece is also missing a *Baptist Pointing at Christ*, which the art historian believes is in the museum in Budapest, as well as a *Temptation in the Desert*, the present whereabouts of which are unknown. A document in the Archives of the Opera del Duomo (of uncertain date, perhaps 1308-9) makes mention of some "little angels above"; on the basis of this information Stubblebine has suggested that the altarpiece had seven pinnacles with busts of angels above the topmost crowning. Four of these panels have come to light (Stoclet Collection, Brussels; Museum of Art, Philadelphia; the J. H. van Heeck Collection, 's Heerenbergh; Mount Holyoke College, South Hadley, Massachussetts), but only the *Angels* in Brussels and Philadelphia are held to be Duccio's work.

Eight of the missing panels are scattered around various museums in America and Europe: *Annunciation*, *Healing of the Blind Man*, and *Transfiguration* (National Gallery, London), *Nativity* between the prophets *Isaiah* and *Ezekiel* and the *Calling of Peter and Andrew* (Washington, National Gallery of Art), *Temptation of Christ on the Mount* (Frick Collection, New York), *Christ and the Samaritan* (Thyssen-Bornemisza Collection, Lugano), *Resurrection of Lazarus* (Kimbell Art Museum, Fort Worth, Texas).

Since thirty-two months are held to be insufficient timewise for the execution of the altarpiece, recent criticism has put forward alternative suggestions regarding the time of execution. Traditionally, the work was done between October 1308 and June 1311. On the one hand, John Pope-Hennessy has argued that since the contract of 9 October 1308 contains no practical suggestions on the execution of the altarpiece, it is not the first draft but a secondary agreement. The work would thus have begun before this date. On the other hand, John White maintains that 9 June 1311 should not be considered the *terminus ante quem* for the completion of the work because the predellas and crowning sections were carried out after its solemn removal to the Cathedral.

Another complicated problem is that of the painter's assistants. Although the contract includes the clause obliging Duccio to work *suis manibus*, it is reasonable to suppose that he had help. For a work of this size it is likely that Duccio made use of artists in his workshop, which was much frequented according to Tizio,

24

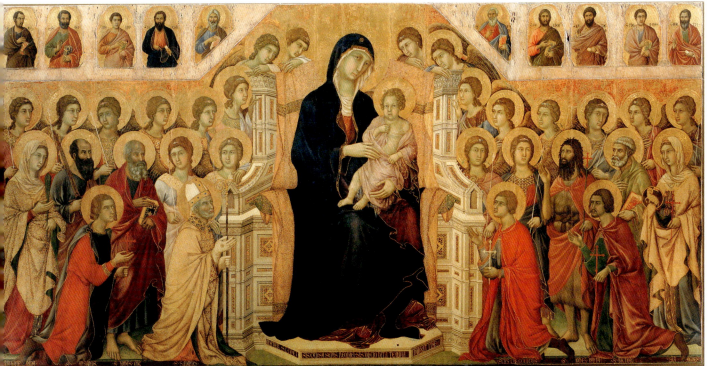

21. Madonna and Child Enthroned with Angels and Saints
370x450 cm
Siena, Museo dell'Opera del Duomo

who wrote, circa 1530: *ex cujus officina veluti ex equo Troiano pictores egregii prodierunt* (from whose workshop distinguished painters emerged as heroes emerged from the horse of Troy). Stubblebine has suggested a radical division of labour between the master of the workshop and his helpers. On the front, only the prospect and the predella are considered to be Duccio's work (excluding the *Apostles*, attributable to Ugolino di Nerio), while the *Last Days of the Virgin* in the crowning section were painted by Segna di Bonaventura, and the *Angels* in the pinnacles by the Master of the fresco of Casolo. On the back, the *Stories of the Passion* are divided between the Master of Città di Castello, the Master of the Tabernacle no. 35, Simone Martini and Ambrogio Lorenzetti. The crowning section is also assigned to Ambrogio, and the predella to his brother Pietro. The uniformity of style evident throughout the whole work was achieved by strict adherence to a common model imposed by Duccio, which was faithfully reproduced on a large scale by the assistants. This theory, although interesting, has not received much support since it seems to ignore the whole concept of the medieval workshop. In surroundings where taste and inclination were identical, the stylistic alternatives adopted by the head of the workshop were realized in a spirit of close collaboration, aiming for overall unity rather than individual characterization. The works produced were therefore formally very similar, stamped by the same basic approach. Bearing in mind the strong diversity of expression apparent in the artists referred to by Stubblebine, it seems impossible to be able to pick out such distinctly separate personalities in a work of such uniformity of feature.

Due to its prevalently narrative character, the interpretation of the work progressed along specific rational lines. It began with the episodes from the *Early Life of Christ*, which were a suitable complement to the prospect, entirely devoted to maternity and the mother-and-son relationship. The narration continued on the back with episodes from the *Public Life of Christ* anticipating the events contained in the twenty-six compartments, where from the *Entry into Jerusalem* to the *Meeting on the Road to Emmaus*, the most dramatic moments of the New Testament are illustrated in great literal detail. In the crowning section the stories of *Christ after the Resurrection*, carrying on from the last episodes of the main composition, completed the back of the work. Finally, the narrative ended with the *Last Days of the Virgin* on the front of the crowning section.

Madonna and Child Enthroned with Angels and Saints

The main feature of the altarpiece is its horizontal form. This is entirely new. Unlike the *Rucellai Madonna* and the *Maestà* in the Cimabue tradition, the Sienese painting is larger, the picture being extended in width. Originally, complete with predellas, crowning section, pinnacles and frames, it must have measured about five metres by five and covered the whole length of the altar, dominating the apse. Its formal grandeur is justified by the nature of the work: as a great devotional picture it was intended for common worship, for the gaze of the faithful. The inscription along the lower edge of the throne, by which the city consecrates its spiritual submission, is not the only confirmation of its votive nature. Accurate restoration (from 1953 to 1958) revealed that the faces of the Madonna and Child were badly damaged as a result of being "riddled with nails driven in to hold up rosaries and other ornaments". The altarpiece was therefore not only an object of sacred monumentality but fulfilled a specific cult role in direct and tangible ways.

The movements of the heavenly court are articulated with subtle symmetry: the characters surrounding the Virgin are divided into two ranks by the throne, which is the central axis of the entire composition. While the mirror-like correspondence of the two sides is broken up by tiny details (the gestures of the saints or the glance of an angel), Mary stands out from the rest of the group. Her extraordinary size proclaims her as the unchallenged protagonist, even in respect of the Child, who is neither making a gesture of benediction nor turning towards his mother but is silently watching the faithful. The angels, perfectly distributed spatially, acquire greater naturalness around the throne, on which they are lightly leaning. The throne itself, decorated with inlaid polychrome marble, is depicted "open like a book" (an appropriate definition by Giulio Carlo Argan), in a frontal position with widened-out sides. Next to the angels, from left to right, are saints Catherine of Alexandria, Paul, John the Evangelist, John the Baptist, Peter, and Agnes, recognizable by their symbols and names painted on the lower edge (the inscriptions are missing only for Paul and Peter). On the bottom row are the four patron saints, also identifiable by their names: Ansano, baptizer of the Sienese and decapitated in the Val d'Arbia in the fourth century; Savino, a martyred bishop; Crescenzio, a boy martyred under Diocletian, whose remains were transferred to the Cathedral in 1058; Victor, a Christian soldier, native of Syria, proclaimed patron after 1288. Above, in little arches whose frames have been lost, are the apostles distinguished by their abbreviated names against the gold background. Again

from left, they are, Thaddeus, Simon, Philip, James the Great, Andrew, Matthew, James the Less, Bartholomew, Thomas and Matthias. The use of gold as a precious complement to the glorification of Mary is essential. The background, the haloes, the garments of the Child, of Catherine, Savino, and Agnes, the cloth covering the back of the throne and the Cosmatesque inlays of the latter, all dazzle the onlooker with their splendid glitter. The fabric of the garments and the backcloth are embroidered with a continuous small golden pattern which gives the effect of real material. Little space is left for the use of other colours. In harmony with the profusion of gold, the choice falls on warm tints (shades of opaque reds, greens, blues and browns) while the Virgin is wrapped in a mantle of an intense ultramarine blue.

22-25. Madonna and Child Enthroned with Angels and Saints, details
Siena, Museo dell'Opera del Duomo

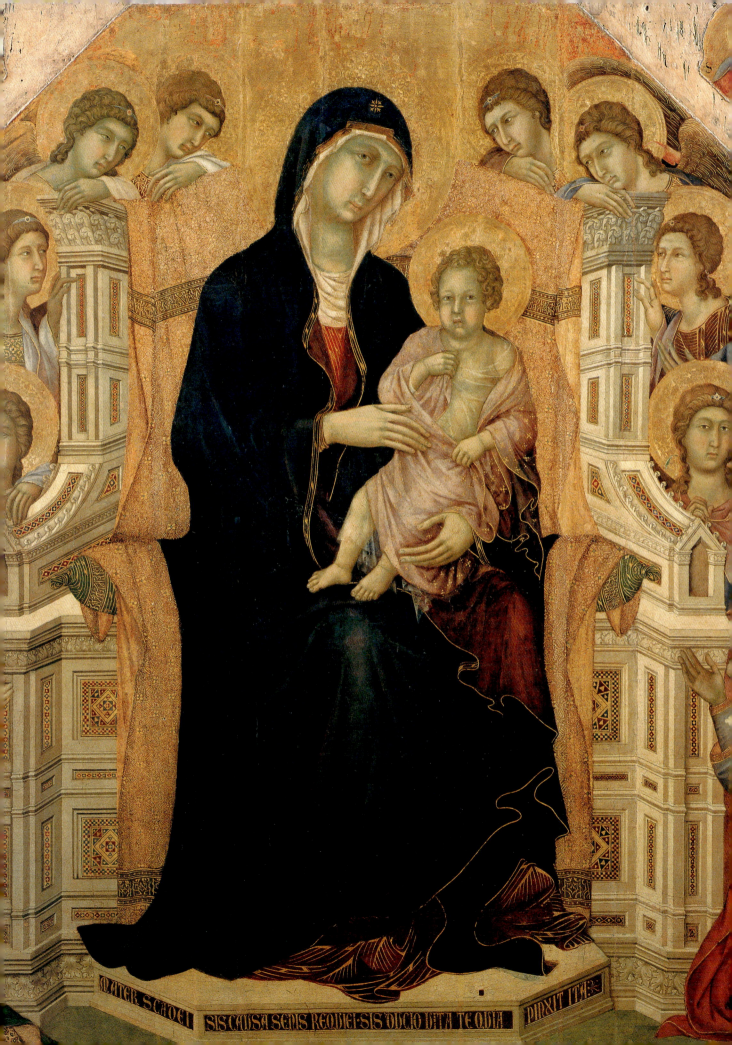

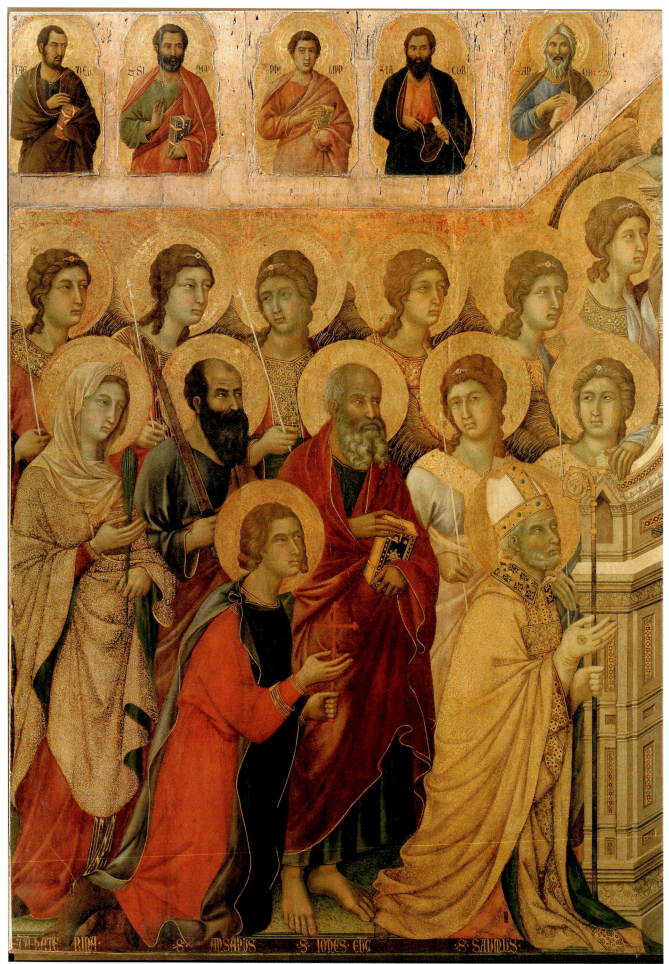

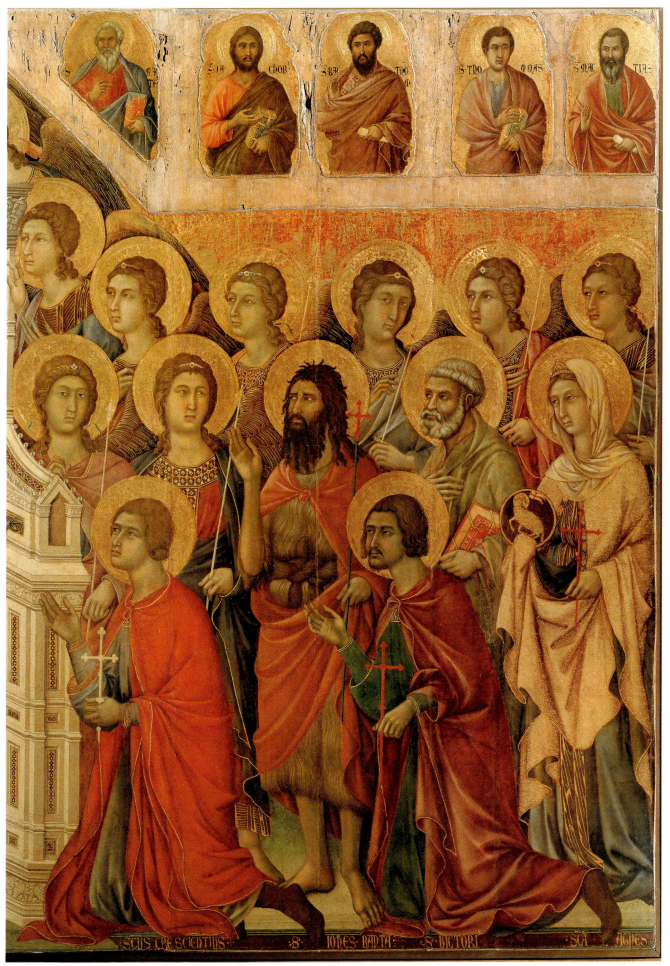

SCHS CRESCIENTIUS · S · IOHES · BAPTA · S · DIOTORI · SCA · AGNES

25

The Early Life of Christ, front predella

An analysis of the style confirms the theory that the predellas and crowning sections were executed after the main panels; the spatial solutions, the slender forms and the harmonic interchange between the action and the setting reveal firmness and confidence. Again, there is stylistic evidence that the episodes of the *Early Life of Christ* were the first to be painted. Critics generally agree over the reconstruction of the predella. From the left were the *Annunciation*; *Isaiah*; the *Nativity*; *Ezekiel*; the *Adoration of the Magi*; *Solomon*; the *Presentation in the Temple*; *Malachi*; the *Slaughter of the Innocents*; *Jeremiah*; the *Flight into Egypt*; *Hosea*; the *Disputation with the Doctors*.

ANNUNCIATION; ISAIAH; NATIVITY; EZEKIEL

The episode of the Annunciation, told only by Luke, is set in vividly articulated architectural surroundings, where consistency of line and colour lend harmonic energy to the whole. Gabriel is portrayed in movement, in the act of greeting (his hand and right foot are the opposite ends of a perfect diagonal), while Mary appears to be drawing back. She is illuminated by the ray of the Holy Spirit, in the form of a small white dove, penetrating from a cusped arch. The unreal perspective of the vase of lilies, reminiscent of Oriental art, has often been noted. The panel is in the National Gallery of London.

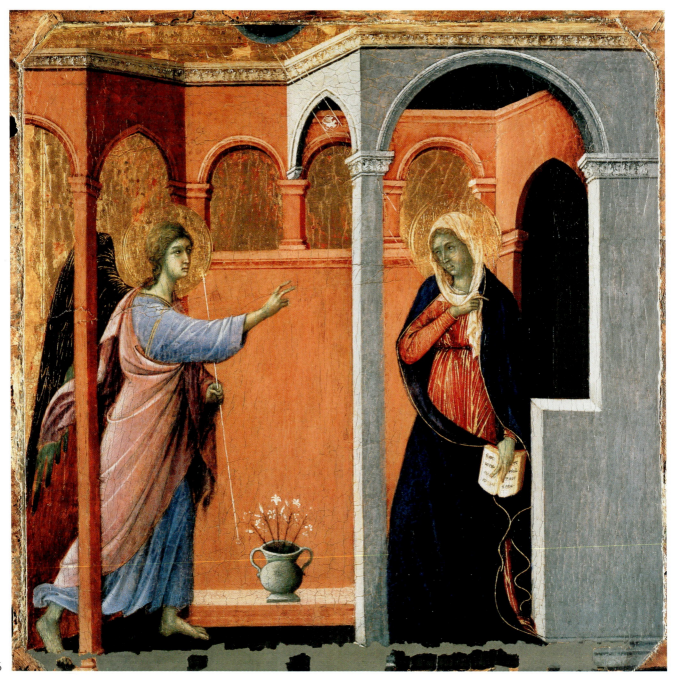

26

Although remaining faithful to Byzantine iconography, the *Nativity* scene pays greater attention to space, which is well distributed and amplified by the measured rhythm of the gestures. The narrative is enriched with descriptive details, combining facts drawn from Luke and from the apocryphal gospels, such as the two midwives bathing the Child (probably Salome and Zelomi) and the ox and the ass, while Joseph is portrayed in his usual thoughtful attitude, sitting outside the grotto.

The statues carved on the Cathedral facade have been identified as the most likely models for the figures of the *prophets*. In spite of their small size they preserve a solemn aspect, and the linearity of contour is enhanced by the gleaming gold ground. The words written on the angel's scroll are unfortunately illegible, but the prophet Isaiah's can be read: *Ecce virgo concepiet et pariet filium et vocabitur nomen eius Emmanuel* (Isaiah 7, 14: And a virgin will conceive and bear a son and his name will be Emmanuel). Ezekiel's scroll reads: *Porta haec clausa erit; non aperietur, et vir non transibit per eam* (Ezekiel 44, 2: This gate shall be kept shut: it shall not be opened, and no man may pass through it). The panel is in the National Gallery of Art in Washington.

26. Annunciation
43x44 cm
London, National Gallery

27, 28. Isaiah; Nativity, with detail (27); Ezekiel
Each prophet 43.5x16 cm
Central scene 43.5x44.5 cm
Washington, National Gallery of Art

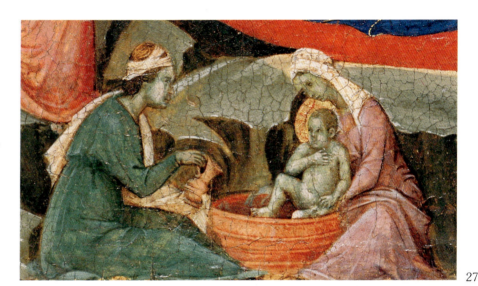

27

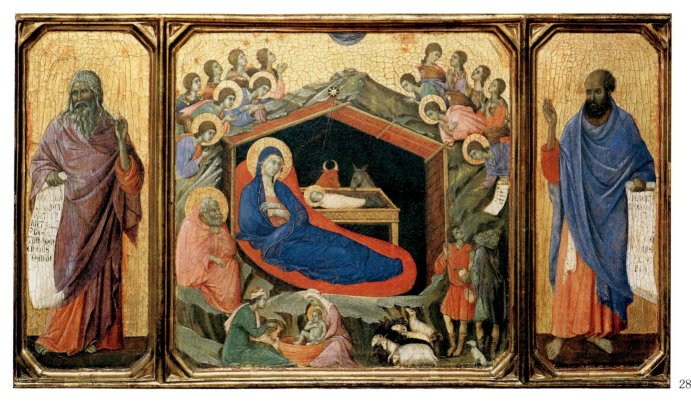

28

ADORATION OF THE MAGI; SOLOMON; PRESENTATION IN THE TEMPLE; MALACHI

The prophet with a crown could be either David or Solomon, but the inscription on the roll, referring to the *Adoration of the Magi*, seems to be more appropriate to the latter: *Reges Tarsis et insulae munera offerunt; reges arabum et Saba dona adducent* (Psalms 72, 9: The kings of Tarshish and the islands shall bring offerings; the kings of the Arabs and of Sheba shall present gifts). The other prophet is Malachi, whose figure in Carli's opinion is reminiscent of the *Plato* by Giovanni Pisano on the Cathedral facade, and who announces the theme of salvation: *Veniet ad templum sanctum suum dominator dominus quem vos queritis, et angelum testamenti quem vos vultis* (Malachi 3,1: The Lord whom you desire will enter his holy temple, and the messenger of the convenat whom you yearn for).

In the *Adoration of the Magi* the detail of the king holding his crown on his arm while bending to kiss the child's feet is taken from the pulpit by Nicola Pisano. It is equally interesting to note the two camels, an evident reminder of the eastern origins of the Magi, while a star, badly damaged through loss of colour, shines above the grotto.

In the *Presentation in the Temple* the consecration rite takes place in a graceful architectural setting of marble enlivened by polychrome inlays, that reproduces the ecclesiastical environment with strong allusion to contemporary religious buildings.

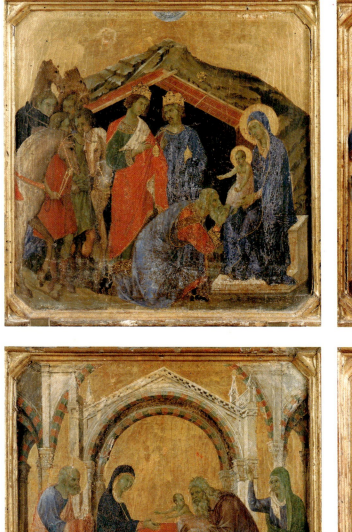

29

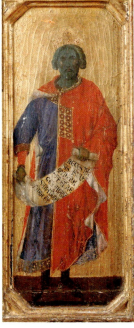

30

29. Adoration of the Magi
42.5x43.5 cm
Siena, Museo dell'Opera del Duomo

30. Solomon
42.5x16 cm
Siena, Museo dell'Opera del Duomo

31. Presentation in the Temple
42.5x43
Siena, Museo dell'Opera del Duomo

32. Malachi
42.5x16 cm
Siena, Museo dell'Opera del Duomo

31

32

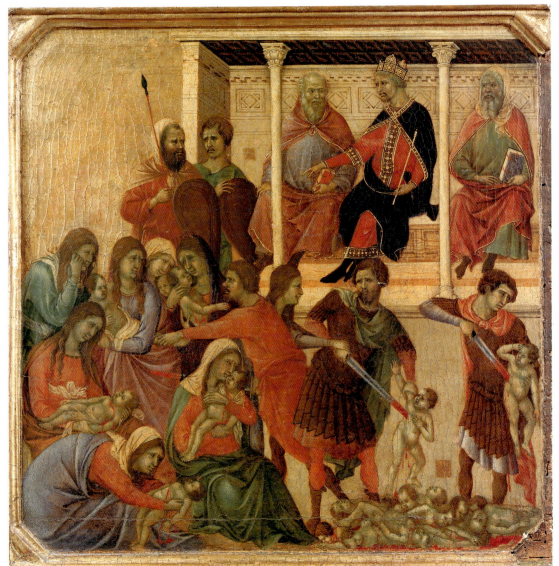

34. Jeremiah
42.5x16 cm
Siena, Museo dell'Opera
del Duomo

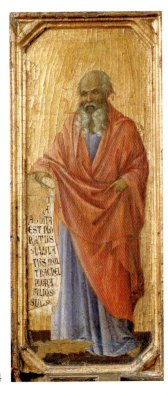

34

SLAUGHTER OF THE INNOCENTS; JEREMIAH; FLIGHT INTO EGYPT; HOSEA; DISPUTATON WITH THE DOCTORS

The scene of the *Slaughter of the Innocents* (which also portrays Herod in the act of ordering the slaughter) is fully explained in the scroll of the prophet Jeremiah, where one can read: *Vox in Rama audita est, ploratus et ululatus multus: Rachel plorans filios suos* (Jeremiah 31, 15: A cry is heard in Rama, a groaning and bitter lamentation: Rachel is weeping for her sons). The despair of the weeping mothers who form an animated group is dramatically conveyed; they are in contrast to the rhythmic, unhurried gestures of the two soldiers who continue the destruction unmoved.

The *Flight into Egypt* also includes two scenes. On the left is the figure of Joseph asleep. The writing on the scroll consisting of the words of the angel who appeared to him explains his warning dream: *Accipe puerum et matrem eius et fuge in Egitum* (Matthew 2, 13: Take the child and his mother and go into Egypt). The harsh rocky crags and small green trees are the

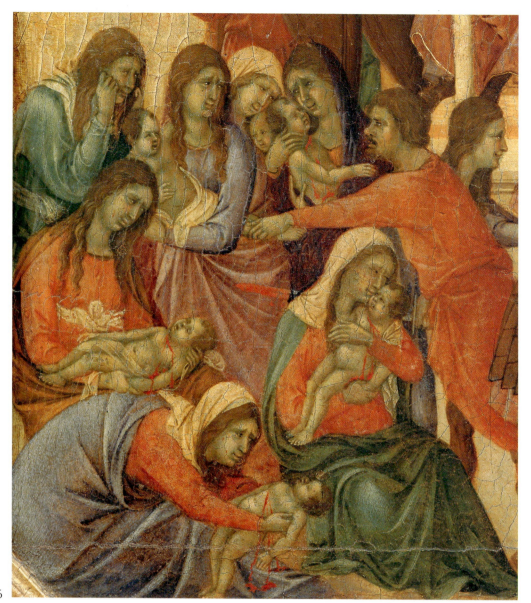

35

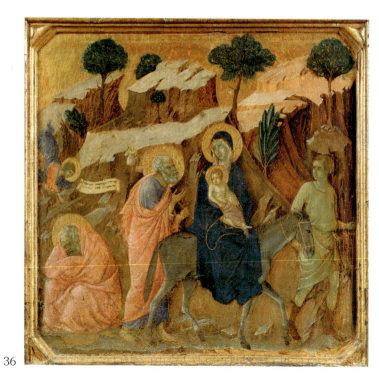

36

37

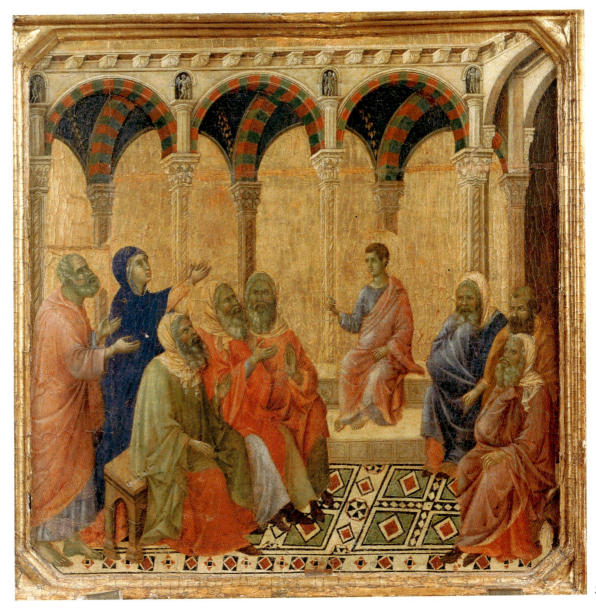

38,39. Disputation with the Doctors, and detail 42.5x43 cm Siena, Museo dell'Opera del Duomo

38

39

background to the journey (the boy leading the donkey is not mentioned in the canonical gospels), while Hosea's roll gives the following comment on the scene: *Ex Egipto vocavi filium meum* (Hosea 11, 1: I have called my son out of Egypt).

The last compartment of the front predella is devoted to the *Disputation with the Doctors*, recounted both in the gospel according to Luke and in the apocryphal writings of Matthew and the Infancy of Christ. The interior of the temple, dominated by a gaily coloured floor (described by Brandi as a "Caucasian carpet"), includes sophisticated details such as the four Cupids enclosed in little niches and the capitals of the slender pillars silhouetted against the gold background.

Scenes from the Public Life, back predella

Originally the *Scenes from the Public Life*, which formed the subject of the compartments of the back predella, began logically with a *Baptism of Christ*, now lost. Of the various suggestions as to the original order, the most generally accepted one is the following: the *Baptism* (lost), the *Temptation on the Temple*, the *Temptation on the Mount*, the *Calling of Peter and Andrew*, the *Wedding at Cana*, *Christ and the Samaritan*, the *Healing of the Blind Man*, the *Transfiguration* and the *Resurrection*.

TEMPTATION ON THE TEMPLE; TEMPTATION ON THE MOUNT

The panels illustrating the second and third temptations of Christ (the first one, in the wilderness, is thought to have been on the smaller side, imagining the predella as a three-dimensional structure) display considerable progress in the composition and arrangement of space. The tiled floor and the pillars, visible in the interior of the building in the *Temptation on the Temple*, are rendered successfully in perspective; they accompany the polygonal form of the building, without breaking up its rigorous geometry.

In the *Temptation on the Mount* the majestic grandeur of all the kingdoms of the world is depicted with superb skill. The imaginative power of the architecture, in clear and luminous shades, is extraordinary: loggias and battlements alternate with round bell-towers, red-tiled roofs and Gothic windows, all protected by solid encircling walls. The panel is in the Frick Collection in New York.

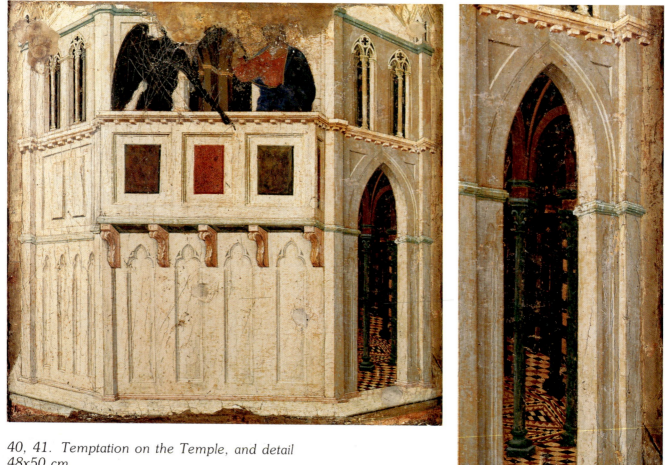

40

40, 41. Temptation on the Temple, and detail
48x50 cm
Siena, Museo dell'Opera del Duomo

42. Temptation on the Mount
43x46 cm
New York, Frick Collection

41

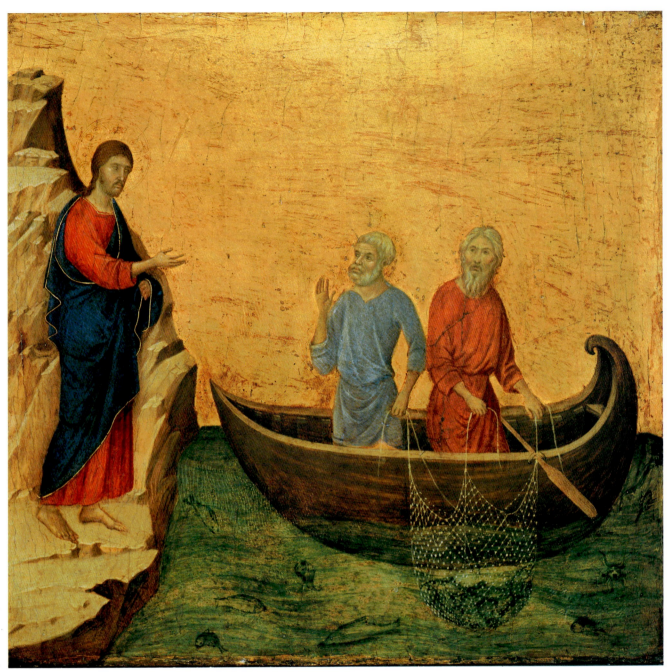

43

CALLING OF PETER AND ANDREW; WEDDING AT CANA

The panel with the *Calling of Peter and Andrew* is in the National Gallery of Art in Washington. Although adhering to the iconographic schemes of Byzantine and local art (clearly related to the scene on the same subject in the thirteenth-century *Altarpiece of St Peter* in the Pinacoteca at Siena) it pays greater attention to the overall composition. The distribution of space is regular and the surroundings simple; the figures are felicitously placed between the transparency of the sea and the gold of the sky.

The panel with the *Wedding at Cana* is livelier and greater importance seems to have been given to the descriptive details than to the narration. The eye is drawn to the cheerfully laid table, embellished with the

44

43. *Calling of Peter and Andrew*
43.5x46 cm
Washington, National Gallery of Art

44. *'Master of St. Peter', second half of the 13th century*
St Peter Altarpiece, detail of the Calling of Peter and Andrew
Siena, Pinacoteca

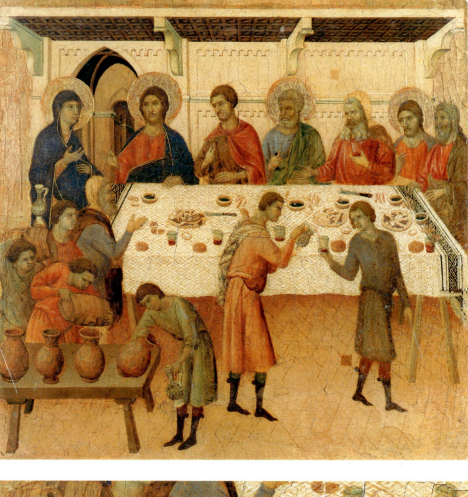

45

45, 46. *Wedding at Cana, and detail*
43.5x46.5 cm
Siena, Museo dell'Opera del Duomo

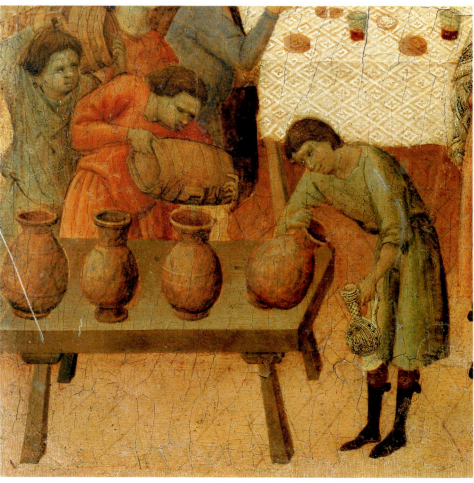

46

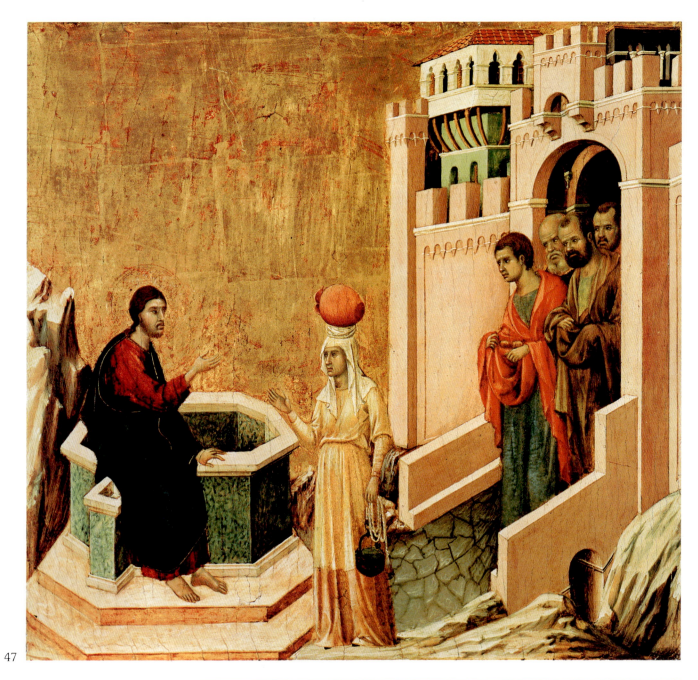

47

47, 48. Christ and the Samaritan, and detail 43.5x46 cm Lugano, Thyssen-Bornemisza Collection

48

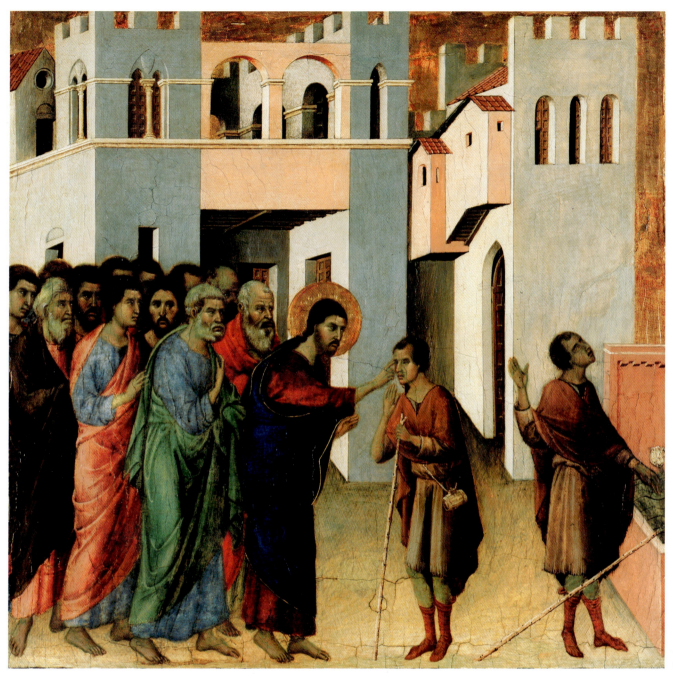

49

49. Healing of the Blind Man
43x45 cm
London, National Gallery

precision of a miniaturist, and to the quick movements of the servants. Without the presence of the bride and groom the picture has a genuine commemorative purpose: that of celebrating the first miracle performed by Christ. In the foreground are small casks out of which water is gushing, fat-bellied water jars, jugs and glasses now full of wine.

CHRIST AND THE SAMARITAN; HEALING OF THE BLIND MAN

Once again urban architecture, accurate and regular in its structural lay-out, lends colour to the scenes. In *Christ and the Samaritan* (in the Thyssen-Bornemisza Collection in Lugano) the geometrical compactness of the city of Sichar and the well on which Christ is sitting are in contrast with the slight figure of the woman.

The same use of space through a delicate balance of scene is to be found in the *Healing of the Blind Man*. The followers of Christ are grouped in front of a massive crenellated building, while the figure of the blind man, repeated in two distinct narrative moments, is placed in a more open area: the short stretch of road. The compartment is in the London National Gallery.

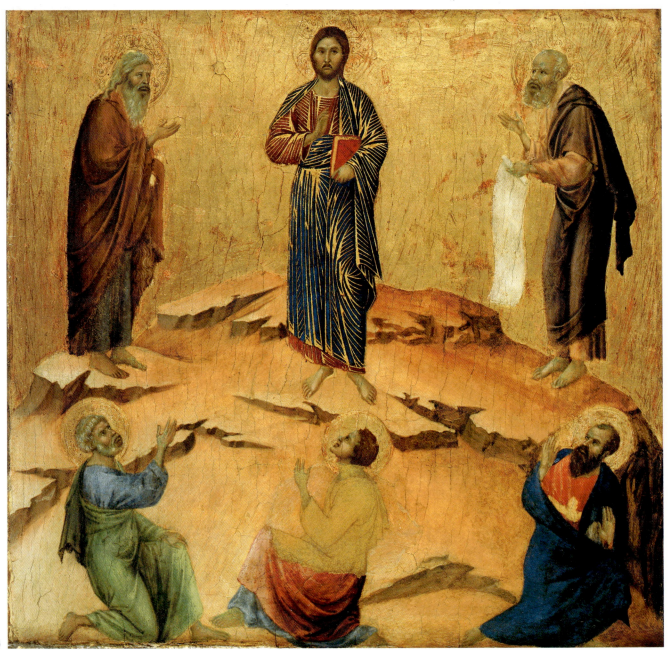

50

TRANSFIGURATION; RESURRECTION OF LAZARUS
The abundant use of gold in the *Transfiguration*, giving it an atmosphere of luminous transparency, is most appropriate to this scene. Peter, John and James, with Moses and Elijah, surround Christ, who is standing immobile in his lavishly highlighted robe. This last particular is conspicuous in the episodes after Christ's death, as if to underline the miraculous nature of the appearances. The painting is in the London National Gallery.

On the bottom right of the *Resurrection of Lazarus* is what remains of a fairly drastic change of mind. Originally the tomb was a horizontal sarcophagus placed at the foot of the hill on which Lazarus was probably sitting. The result was evidently not to the artist's satisfaction and the sarcophagus was transformed

50. *Transfiguration*
48x50.5 cm
London, National Gallery

51. *Resurrection of Lazarus*
43.5x46 cm
Fort Worth (Texas), Kimbell Art Museum

into a sepulchre dug out of the rock. This change also affected the resurrected figure, which as a consequence assumes a peculiar oblique position. The spontaneous gesture of the character sitting beside the open tomb and holding his nose is remarkably lifelike. The picture is in Texas in the Kimbell Art Museum at Fort Worth.

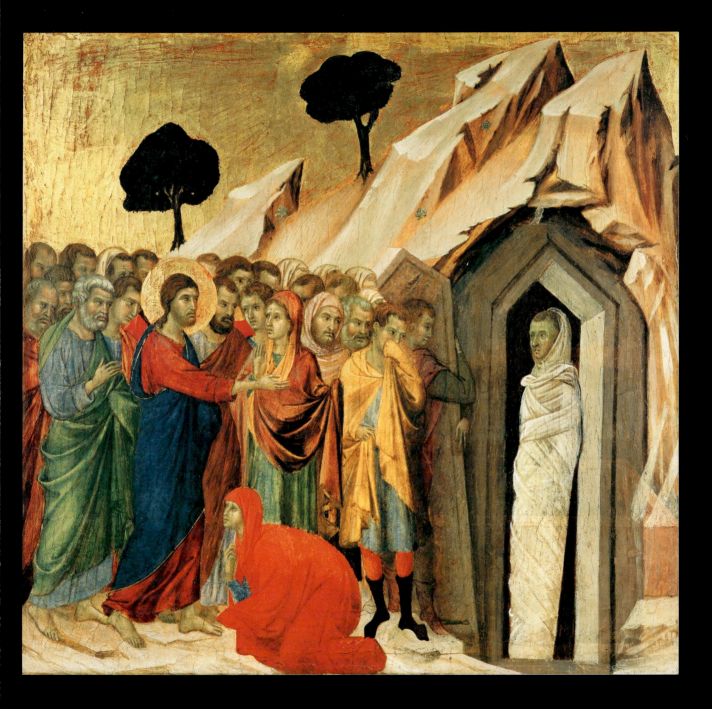

Stories of the Passion

It is interesting to note the different function of the scenes represented on the two sides of the *Maestà*. The front side was a devotional image destined for the community of the faithful (which explains its size, clearly visible from every corner of the church), while the back was essentially a narrative cycle intended for the closer observation of the clergy in the sanctuary. The main element of the back consisted of fourteen panels, originally separated by little columns or pilasters (of about 4 cm) which were lost, together with the outside frame, in the dismembering of 1771. Except for the *Entry into Jerusalem* and the *Crucifixion*, each panel contains two episodes. The central part of the lower row with the *Agony in the Garden* and *Christ taken Prisoner* is twice as wide as the other compartments (but the same as the *Crucifixion* panel) because the events portrayed are composed of different narrative units. Numerous contrasting theories have been advanced by critics for the order of interpretation, rendered problematical by the variety of New Testament sources drawn on by Duccio. It is certain that the cycle began at the bottom left and ended at the top right, proceeding from left to right first on the lower row and then on the upper.

ENTRY INTO JERUSALEM

The scene is unusual because of the attention given to the landscape, which is rich in detail. The paved road, the city gate with battlements, the wall embrasures, the slender towers rising up above and the polygonal building of white marble reproduce a remarkably realistic layout, both urbanistically and architecturally. The small tree, withered and leafless, that shows behind Christ's halo, is the fig-tree that Christ found without fruit. Florens Deuchler has suggested that the literary source is a historical work of the first century A.D., the *De Bello Judaico* by Flavius Josephus which was well-known in the Middle Ages. The panel by Duccio is a faithful reproduction of the description of Jerusalem in Book V. Infrared photography during restoration has revealed several changes of mind regarding the area around the tree in the centre and the road.

52. Stories of the Passion
212x425 cm
Siena, Museo dell'Opera del Duomo

53. Entry into Jerusalem
100x57 cm
Siena, Museo dell'Opera del Duomo

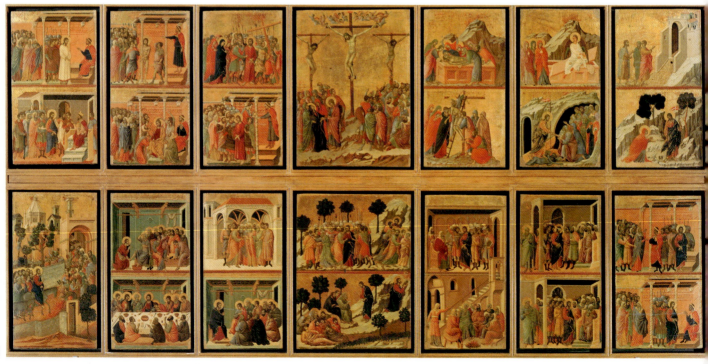

52

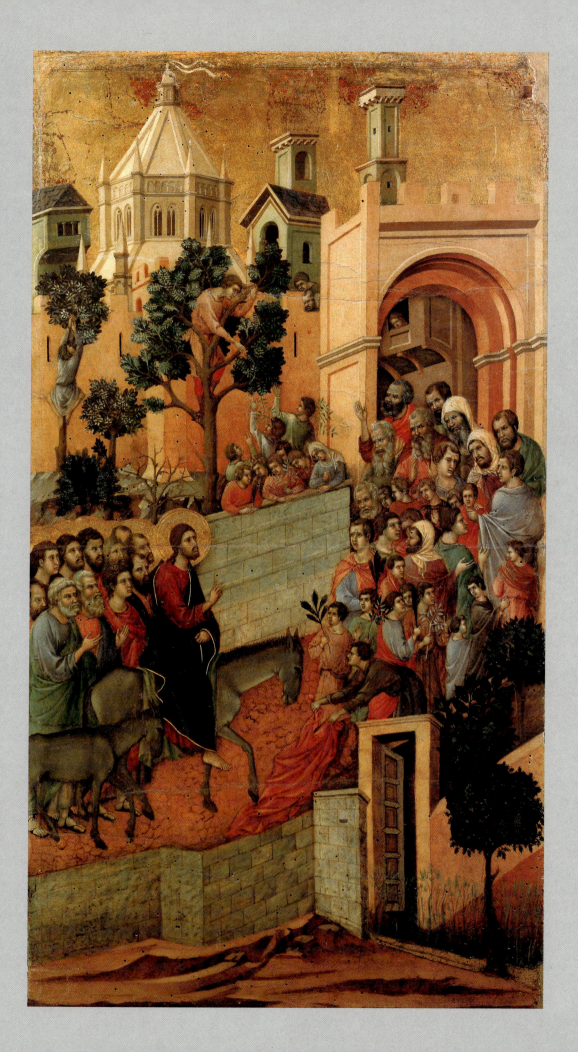

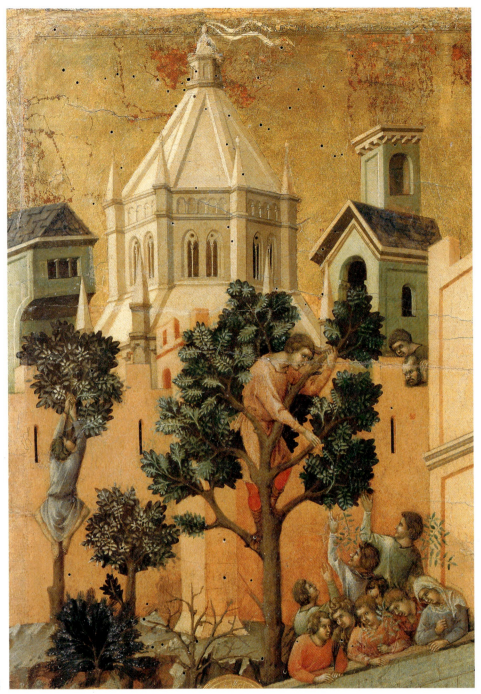

54. Entry into Jerusalem, detail
Siena, Museo dell'Opera del Duomo

55, 56. Washing of the Feet; Last Supper
100x53 cm
Siena, Museo dell'Opera del Duomo

54

WASHING OF THE FEET; LAST SUPPER

Only John tells the story of the *Washing of the Feet* and the events should therefore be read from the top downwards, according to the order in which they occur in this gospel. The setting is the interior, in central perspective, of an unadorned room; the only decorative elements are the coffered ceiling and the multifoiled insert placed on the rear wall. This detail must also be imagined in the *Last Supper*, hidden by Christ's halo, since it reappears in *Christ Taking Leave of the Apostles*, which according to the gospel occurs in the same place.

Echoes from Byzantine art can be seen in the *Washing of the Feet*, in the crowded throng of the apostles and Peter's gesture, while Christ's position recalls

Western models. The shape of the black sandals, aptly described by Cesare Brandi "as if they were precious onyx scarabs", is typical.

The *Last Supper* is dominated by the central figure of Jesus who, to the astonishment of the onlookers, is offering bread to Judas Iscariot (shown in other panels with the same features). An unusual experiment with space has been made with John, whose position is traditional: the head of the favourite disciple is painted in front of the figure of Christ, and his halo behind Christ's shoulders. Wooden bowls, knives, a decorated jug and a meat dish, and the paschal lamb, are set on the table, which is covered with a simple tablecloth woven in a small diamond pattern.

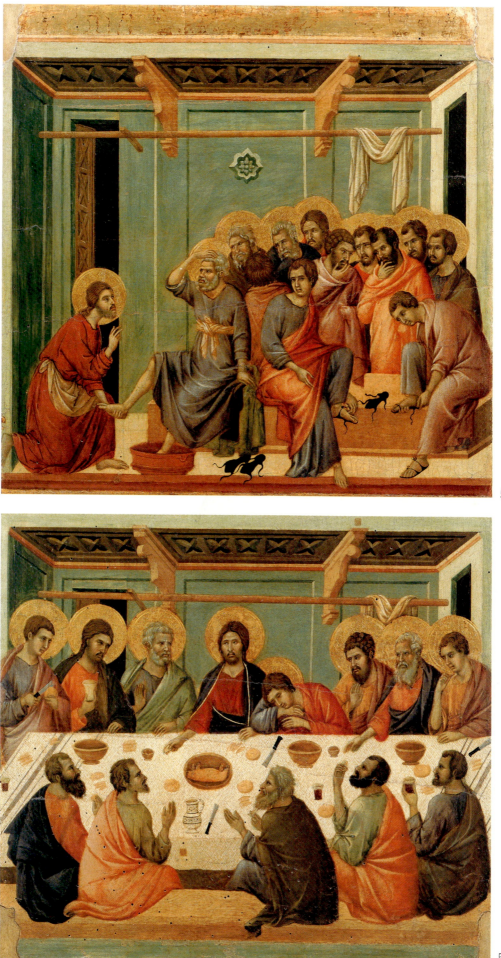

55

56

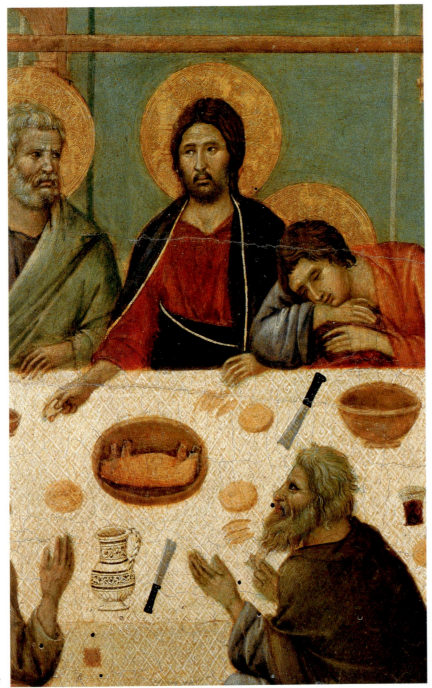

57. Last Supper, detail
Siena, Museo dell'Opera del
Duomo

58, 59. Christ Taking Leave of the
Apostles; Pact of Judas
100x53 cm
Siena, Museo dell'Opera del
Duomo

CHRIST TAKING LEAVE OF THE APOSTLES; PACT OF
JUDAS

Following the story in John again, the scenes succeed each other from the bottom upwards although occurring simultaneously. While Jesus is giving the new commandment to the apostles (now eleven), Judas betrays him for thirty pieces of silver. In *Christ Taking Leave of the Apostles*, his sideways position, shown up by the half-open door, is in contrast to the close-knit group of disciples. They are all turning the same way in thoughtful attitudes, the soft drapery of their coloured robes animating the whole scene. As in the *Washing of the Feet* and the *Last Supper* Duccio has avoided haloes since the conspicuous shape of the golden discs might have created an overpowering effect, besides taking up most of the space in the picture.

The *Pact of Judas* is set in external surroundings where the space is arranged in varying degrees of depth. The group in the foreground, on the same level as the pillar on the right, is gathered in front of a loggia with cross-vaults and round arches. The polygonal tower, a little behind the central building, completes the background.

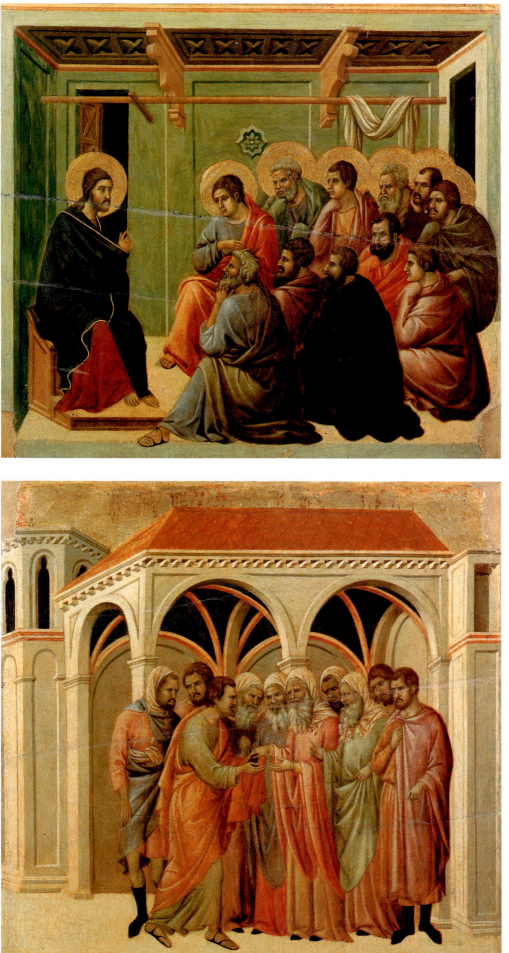

58

59

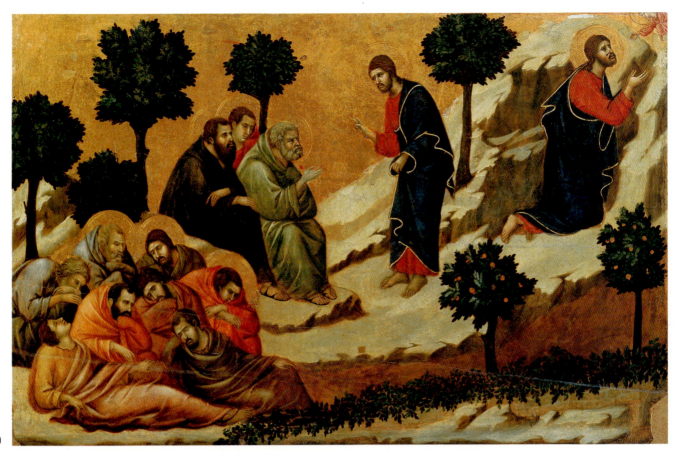

60

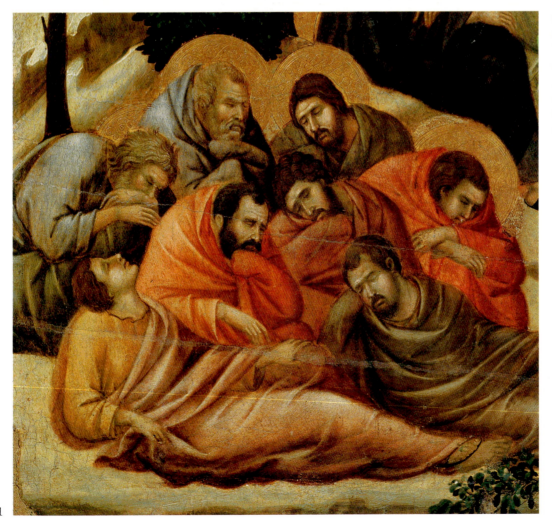

*60-63. Agony in
the Garden; Christ
Taken Prisoner,
and details
102x76 cm
Siena, Museo
dell'Opera del
Duomo*

61

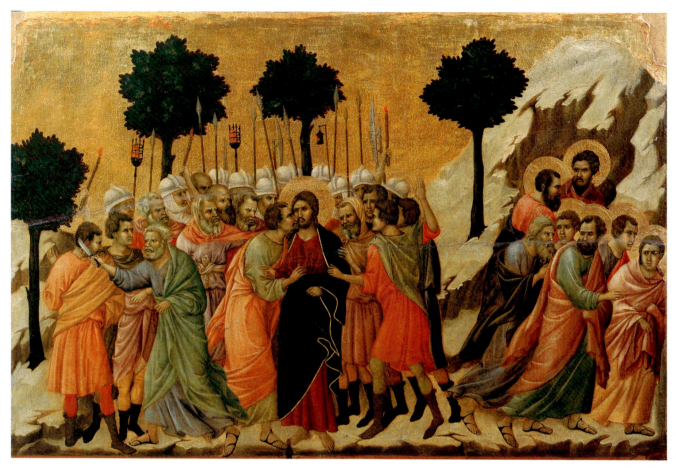

62

AGONY IN THE GARDEN; CHRIST TAKEN PRISONER

This should be read from the bottom upwards, each scene containing different narrative units. In the *Agony in the Garden*, Jesus is turning to Peter, James the Great and John, shaking them and warning them not to fall into temptation, while the other disciples are sleeping. On the right, in accordance with the Gospel of St Luke, which is the only one to mention an angel appearing, he withdraws in prayer. In this quiet setting, both episodes are visualized through the gestures of Christ, Peter and the angel.

The Mount of Olives becomes the scene of unexpected agitation in *Christ Taken Prisoner*, containing three separate episodes: in the centre the kiss of Judas, to the left Peter cutting off the ear of the servant Malchus, to the right the flight of the apostles. The dramatic intensity of the scene, heightened by the crowded succession of spears, lanterns and torches, shows in the excited movements of the characters and the expressiveness of their faces. The landscape, after long being an anonymous feature of minor importance, takes on a new scenic role. The vegetation and rocky crags of Byzantine inspiration seem to be an integral part of the action: in the *Agony in the Garden* the three trees on the right isolate Christ, while in *Christ Taken Prisoner* they enclose the main episode, as if allowing the disciples to escape.

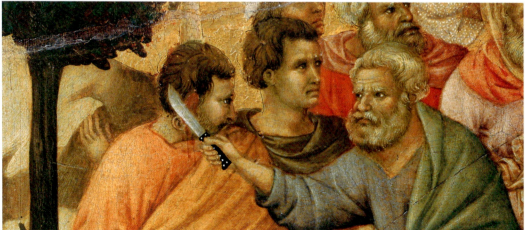

63

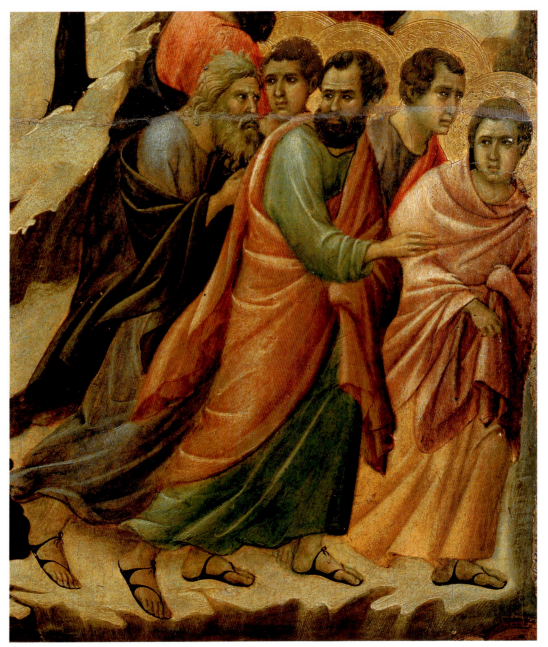

64. Christ Taken Prisoner, detail Siena, Museo dell'Opera del Duomo

65. Christ Before Annas and Peter Denying Jesus 99x53.5 cm Siena, Museo dell'Opera del Duomo

64

CHRIST BEFORE ANNAS AND PETER DENYING JESUS

The rule of absolute autonomy being given to each single scene is successfully broken in this panel. The two episodes, told by John, occur simultaneously but in different places and the stairs, a material link in space, also connect the time-factor. While Jesus is brought before the High Priest Annas, Peter remains in the courtyard where a servant-girl recognizes him as a friend of the accused: his raised hand indicates the words of denial. The surroundings are full of vivid architectural detail: the doorway with a pointed arch opening onto the room with a porch, the Gothic window of the small balcony, the pilaster strips on the back wall of the upper floor and the coffered ceiling, this time with smaller squares. Peter, whose halo in a curious fashion includes the head and shoulders of the person next to him, is warming his feet at the fire in a highly realistic manner. Lastly, because of her vertical position and arm resting on the handrail, the figure of the serving-maid about to go up the stairs was evidently the cause of much indecision since several "changes of mind" have been discovered around the skirt.

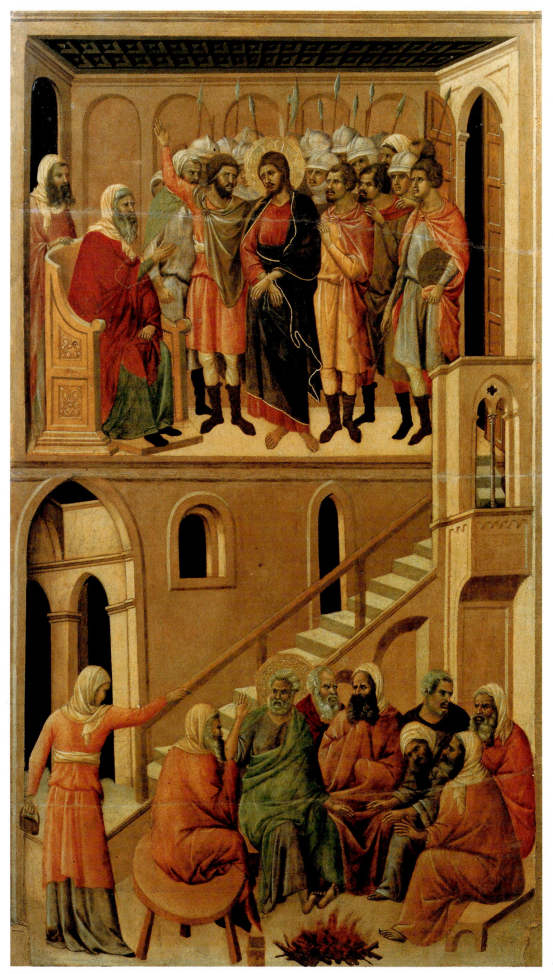

65

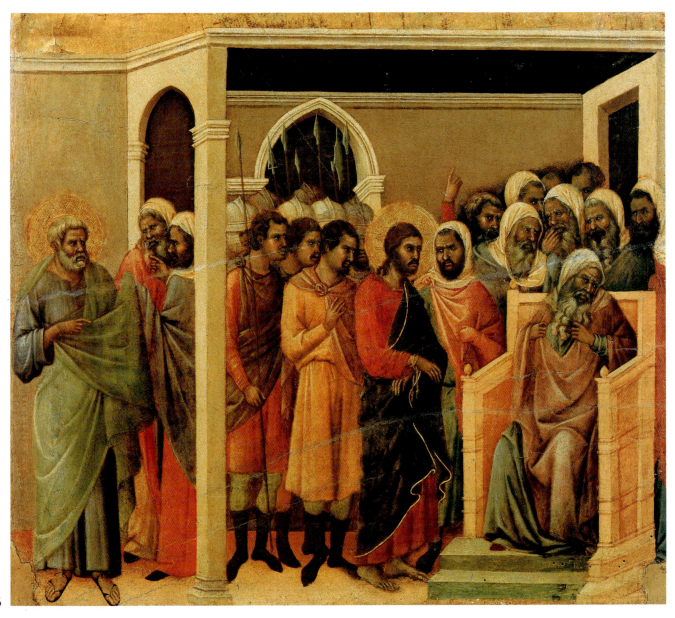

66

CHRIST BEFORE CAIAPHAS; CHRIST MOCKED

According to the Gospel of St. Matthew, the compartment should be read from the bottom upwards. The scenes take place in the same surroundings, the lawcourt of the Sanhedrin, where Christ is brought before the High Priest Caiaphas and the Elders. Outside the room, the cock painted at the top alludes to the second and third denials of Peter. In *Christ Before Caiaphas*, great importance is given to the person with raised hand and pointing finger looking significantly at the onlooker; the affronted gesture, isolated among a crowd of helmets and anonymous faces, catches the attention of the viewer. Caiaphas too is depicted in an attitude of wrath and indignation at the words of Je-

66-69. Christ Before Caiaphas; Christ Mocked, and details 98.5x53.5 cm
Siena, Museo dell'Opera del Duomo

sus: with his hands on his breast he tears his red robes, showing the tunic underneath (this detail is told by Matthew and Mark).

Gestures are more agitated in the scene above where Christ blindfolded (according to the version in Mark and Luke) and immobile in his dark cloak, is mocked and beaten by the Pharisees.

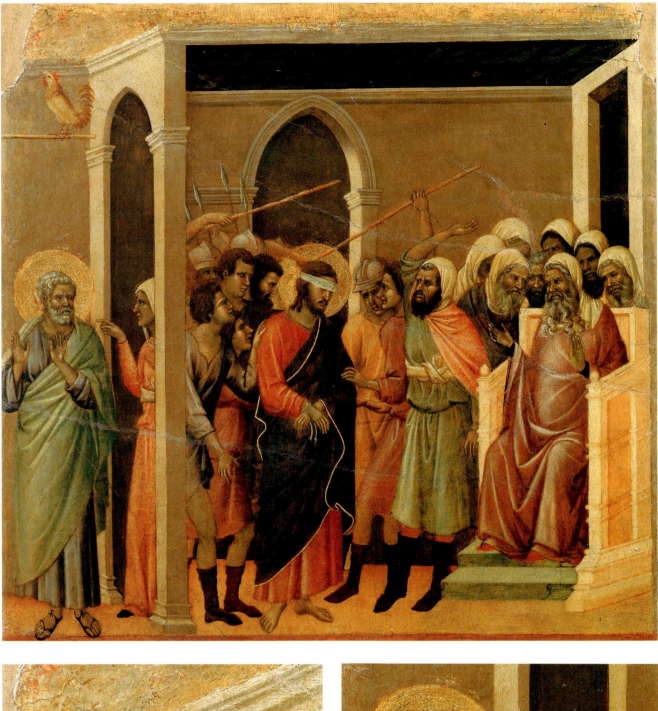

67

68

69

*70-72. Christ
Accused by the
Pharisees, and detail;
Pilate's First
Interrogation of Christ
98x57 cm
Siena, Museo
dell'Opera del
Duomo*

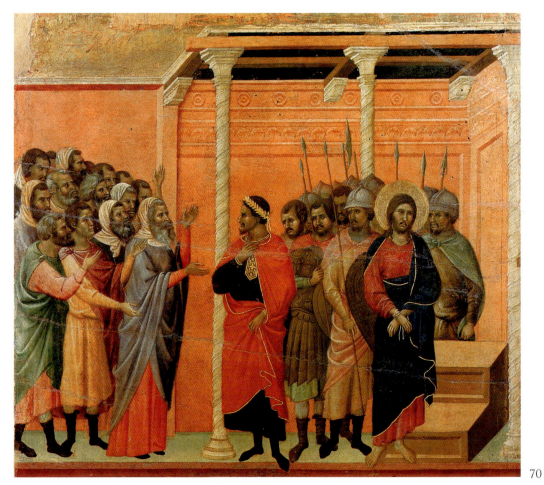

70

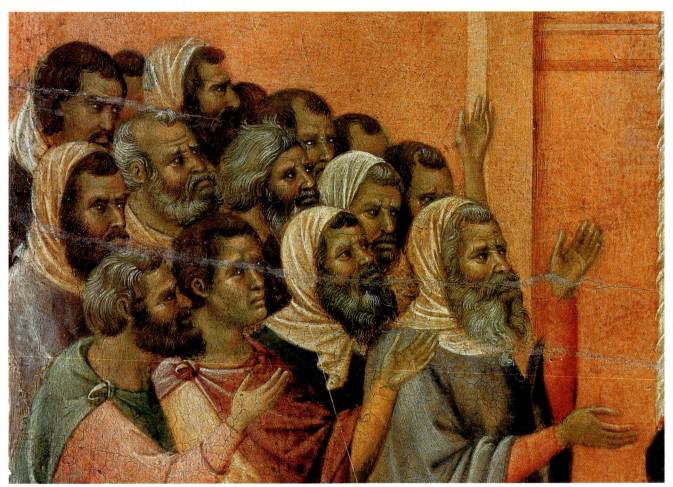

71

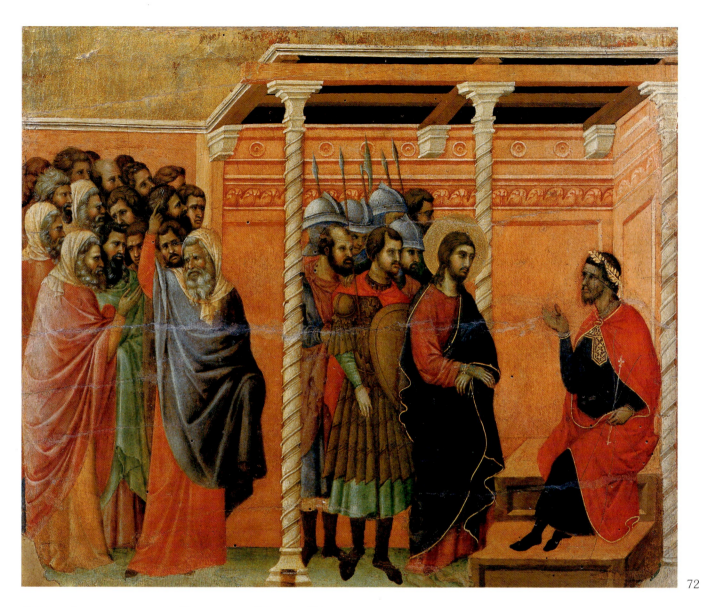

CHRIST ACCUSED BY THE PHARISEES; PILATE'S FIRST INTERROGATION OF CHRIST

The order of the episodes is from the top downwards. The surroundings for the scenes in which Pilate appears are new since the events take place in the governor's palace. The slender spiral columns of white marble and the decoration carved along the top of the walls seem to refer to classical architecture. Pilate too, portrayed with the solemnity of a Roman emperor and crowned with a laurel wreath, evokes the world of classical antiquity. It is interesting to note how the latter's face still bears the slashings caused by medieval religious fervour. The function of the beams placed on the capitals supporting a light and apparently unstable wooden roof is harder to explain. As in the gospel, the group of Pharisees, animated by lively gestures (again the hand with pointing finger), is depicted outside the building: the Jews avoid going inside in order not to be defiled and to be able to eat the Passover meal. In the upper scene, an overwhelming aura of solitude surrounds Christ.

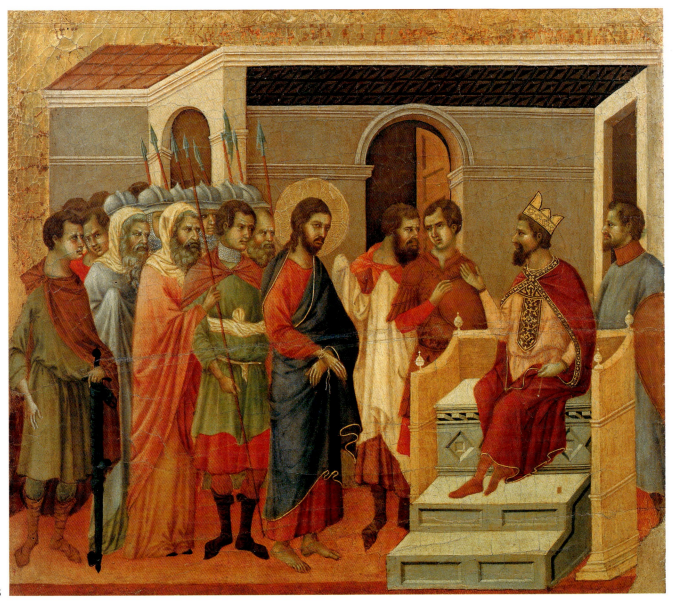

73

CHRIST BEFORE HEROD; CHRIST BEFORE PILATE AGAIN

The narrative continues on the upper row with two episodes passed down by Luke only. Pilate, on learning that Jesus belonged to the jurisdiction of Herod, sent the prisoner to the king to be judged by him. After questioning Jesus and treating him with ridicule and contempt, Herod sent him back to the Roman governor dressed in a conspicuous garment, the white robe that distinguished lunatics. Action proceeds from the bottom upwards; in the lower scene a servant is holding out to Christ the robe which in the upper scene he is already wearing. Although placed in different architectural surroundings (the governor's palace present in the last compartment on the lower row appears again), the arrangement of the two scenes is

73-75. Christ Before Herod; Christ Before Pilate Again, and detail
100x57 cm
Siena, Museo dell'Opera del Duomo

almost identical, both in the distribution of the characters and in their movements. Christ, gazing with extreme sadness at the onlooker, is withdrawn in total silence. Herod anticipates and repeats (*Pilate's First Interrogation of Christ*) the position of Pilate where the solemn movement gives a rather static effect. The king's throne with steps, its basic structure embellished and adorned, is more ornate than the governor's simple wooden seat.

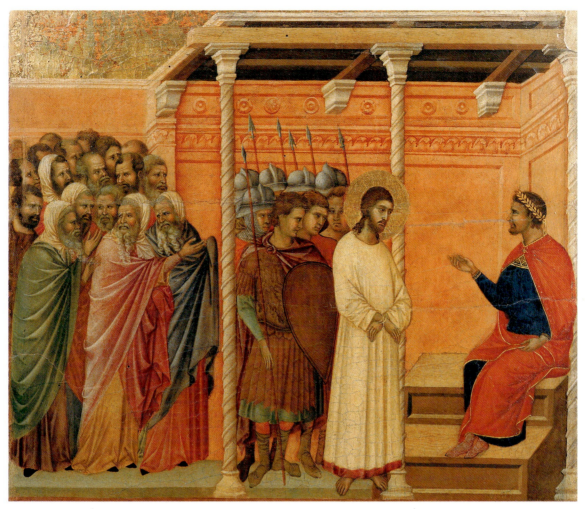

74

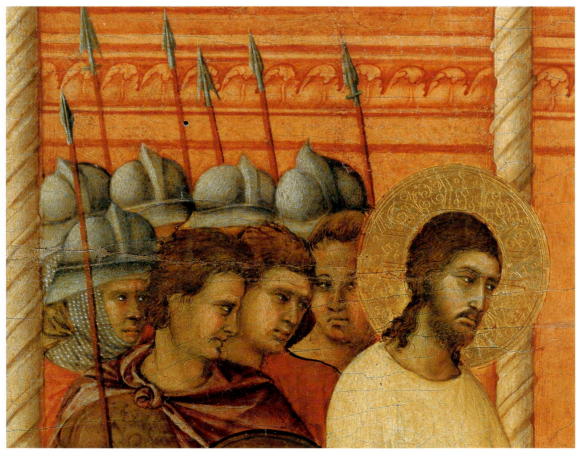

75

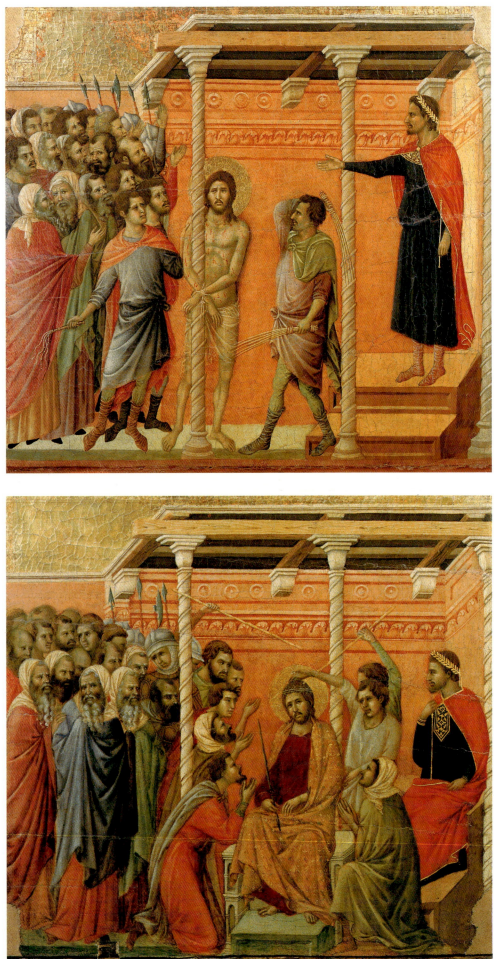

76

77

76-78. *Flagellation, and detail; Crown of Thorns*
100x53.5 cm
Siena, Museo dell'Opera del Duomo

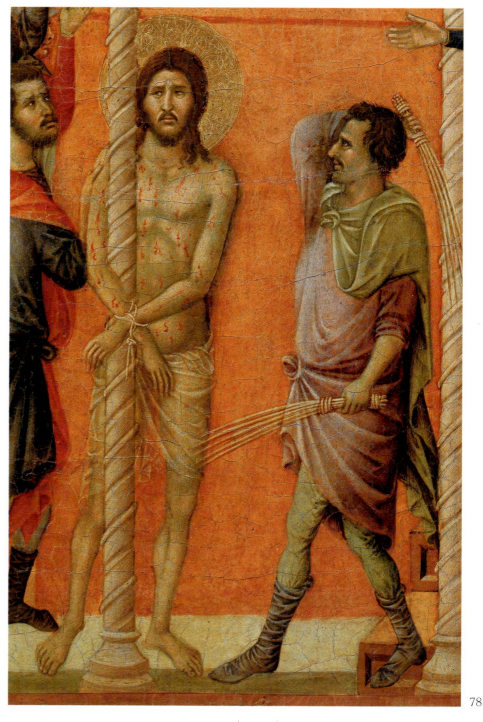

78

FLAGELLATION; CROWN OF THORNS

The scenes should be read from top to bottom even though at this point the pictorial narrative unexpectedly abandons the gospel order of events. Matthew affirms that the episode of Pilate washing his hands comes before both the Flagellation and the Crown of Thorns. Instead in the picture the order is inverted. However, it still adheres faithfully to the written source and the scenes are illustrated in minute detail. Con-

sidering that the *Flagellation* is barely mentioned in the gospels, the descriptive details show remarkable inventiveness, aimed at illustrating each moment of the Passion. The figure of Pilate disobeys all the rules of perspective: although obvious from the seat on which he is standing that he is inside the building, he manages to stretch his arm in front of the pillar, in a position parallel to the horizontal level of the floor.

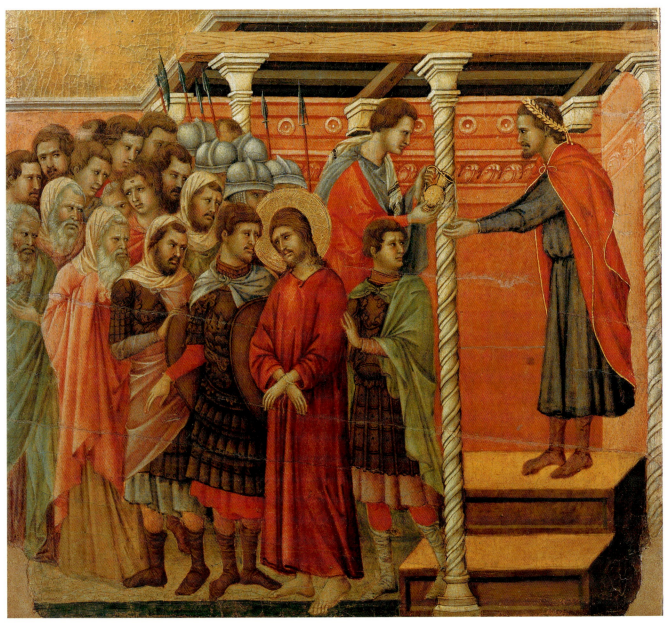

79

PILATE WASHING HIS HANDS; WAY TO CALVARY

The story continues from the bottom to the top. An entire compartment is devoted to Pilate's action, although the story is told briefly and only by Matthew. Again, to lend vitality to each single movement, different planes of perspective are superimposed in the scene, both in the figure of Pilate, and in the large group crowding in front of the left pillar. The base of this should be parallel to that of the column next to it, but it is much further back.

The scene on the *Way to Calvary*, as Duccio represents it, has the specific purpose of acting as an intermediary between past and future events. On the

79-81. Pilate Washing his Hands, and detail; Way to Calvary
102x53.5 cm
Siena, Museo dell'Opera del Duomo

one hand, the slender, erect figure of Christ, with his hands still tied, refers the onlooker to the various stages of the trial. On the other hand, the direction in which all the characters are moving (to the right, towards the panel with the *Crucifixion*) and the cross borne by Simon of Cyrene, allude to the terrible conclusion.

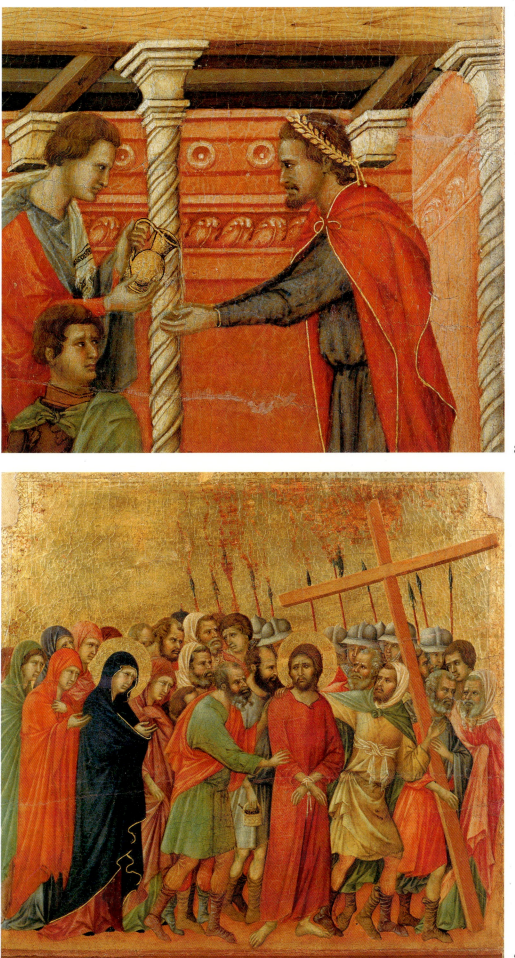

80

81

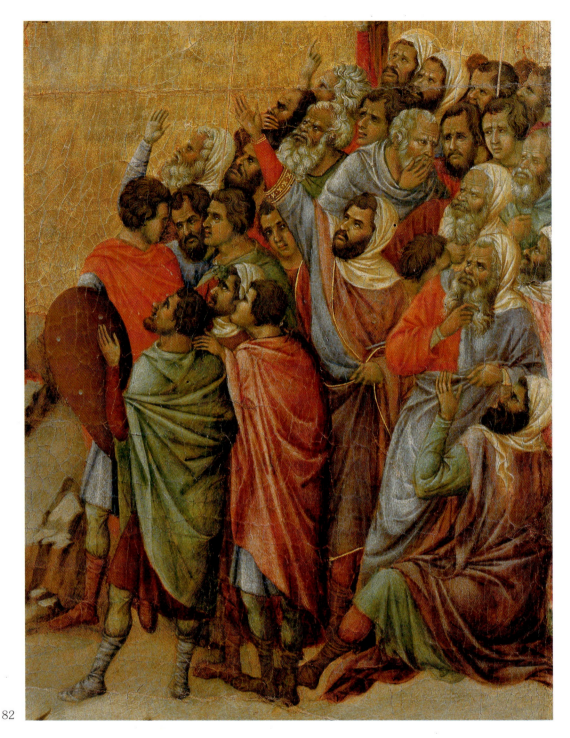

82

CRUCIFIXION

The emotional intensity of the *Stories of the Passion*, from *Christ Taken Prisoner* to the *Way to Calvary*, reaches its most dramatic moment in the *Crucifixion* which, placed in the middle of the upper row, dominates the whole of the back section. The slender cross stands out against the gold ground, dividing the crowd into two separate groups. On the left are Christ's followers, subdued and orderly, their faces drawn with grief, amongst whom are Mary of Clopas, Mary Mother of Jesus, Mary Magdalene (dressed in red with her long hair unbound) and John the Evangelist. On the right, the priests and soldiers are shown mocking and insulting, with rough movements. The

82, 83. Crucifixion, and detail
100x76 cm
Siena, Museo dell'Opera del Duomo

fine modelling of the figure of Christ is reminiscent of the plasticism of Gothic ivories, while the strong contrast of movement which opposes the characters has evident connections with the *Crucifixion* on the Cathedral pulpit, carved by Nicola Pisano from 1266-68. The surroundings are bare and scanty, the jagged rocks clearly alluding to Golgotha.

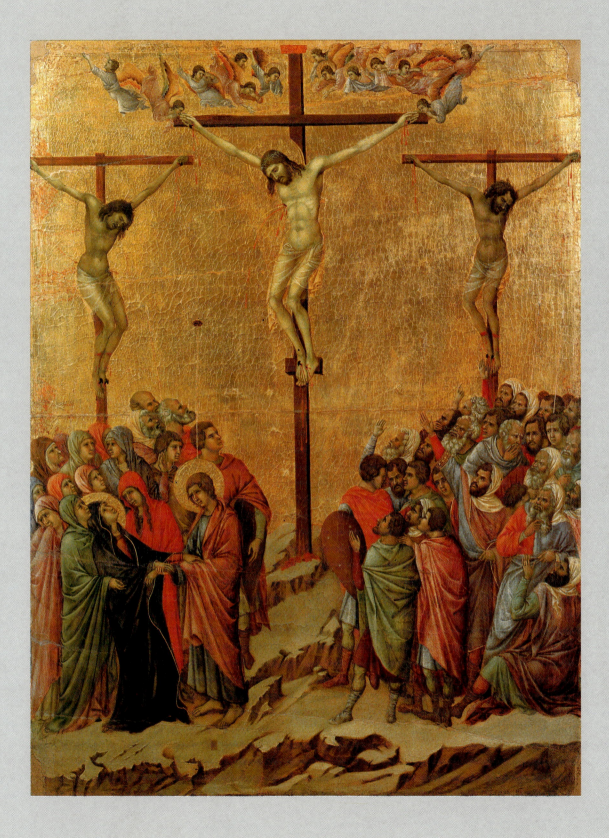

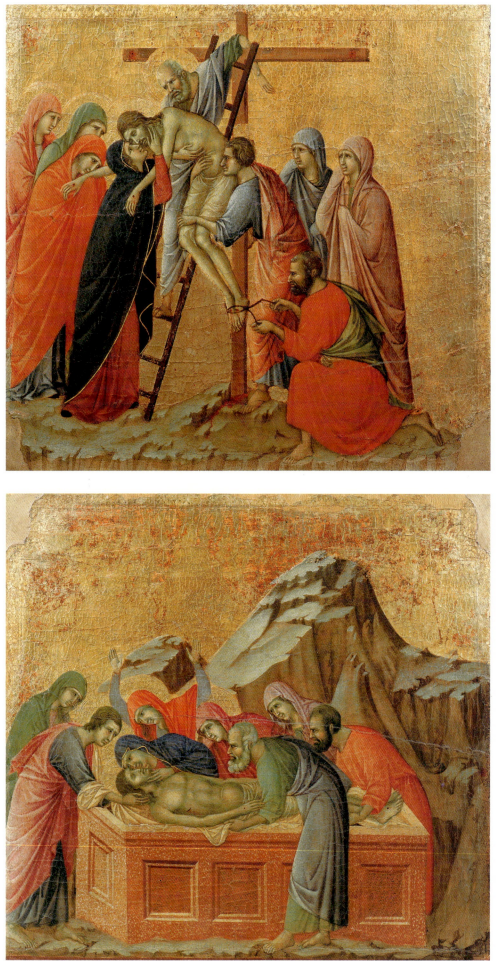

84

85

DEPOSITION; BURIAL

The *Deposition*, with the same gold background as the *Crucifixion* (excluding any possibility of distraction), is represented as intense embracing. Joseph of Arimathaea and John support the lifeless body, while Nicodemus removes the nails from the feet and the Virgin reaches out yearningly to her son, looking into his closed eyes. One of the Marys holds Christ's arm to her face, while the others, their hands covered by their veils, are tragic masks of grief. The little stream of blood under the cross, also present in the previous scene, has a dramatic realism.

The same characters appear in the *Burial* (of the three women, the one with the blue garment is missing), all leaning over Christ's body. Joseph arranges the shroud, John gently lifts Christ's head, Mary kisses him for the last time. Only Mary Magdalene expresses her despair emotionally, lifting both her arms to heaven.

THE THREE MARYS AT THE TOMB; DESCENT INTO HELL

The original order is difficult to establish because the episode of the *Descent into Hell* is not mentioned in the canonical gospels, but recounted in the apocryphal gospel of Nicodemus. Although there are some reservations, most critics agree that the panel should be read from the top downwards. The subtlety of posture in the scene of the *Marys at the Tomb* is outstanding. The women are portrayed in attitudes of wonder and fear; their delicate backwards movement and gesticulating hands show their astonishment at the sudden apparition. For the design of the three figures it would seem that Duccio was inspired by the *Sibyl* carved by Giovanni Pisano on the facade of Siena Cathedral. Opposite, the angel is sitting quietly on the rolled-away stone and pointing to the empty tomb. His white robe (lighter than the shroud draped over the edge of the sarcophagus) wraps him in soft folds which show up well against the dark rocks and illuminate the whole composition.

The Descent into Hell, an iconographic theme little diffused in Western painting, shows clear traces of Byzantine art in the abundant use of gold on Jesus' robe and the unimaginative layout of the scene itself. Having burst open the gates of hell, Christ arrives in limbo to set his forefathers free: while helping Adam to rise, he treads on a hideous Satan, who lies vanquished and blind with rage.

84, 85. Deposition; Burial
101x53.5 cm
Siena, Museo dell'Opera del Duomo

86, 87, 89. The Three Marys at the Tomb, and detail; Descent into Hell
102x53.5 cm
Siena, Museo dell'Opera del Duomo

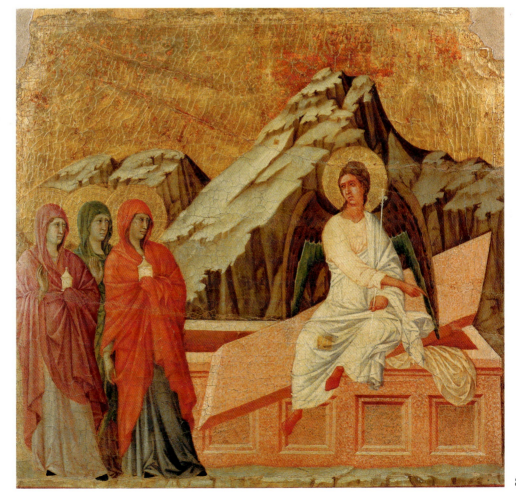

86

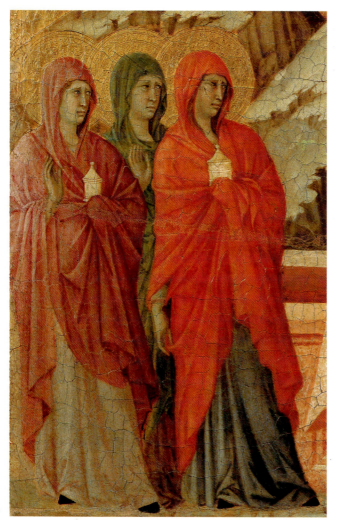

APPEARANCE TO MARY MAGDALENE (NOLI ME TANGERE); MEETING ON THE ROAD TO EMMAUS

The two episodes are read from the bottom to the top. In the *Appearance to Mary Magdalene* the rocky landscape becomes a stage setting: the steep ravines isolate the intimate dialogue in surroundings of absolute solitude, while the trees (which have not appeared, since *Christ Taken Prisoner*) are the only witnesses. Jesus is portrayed as in the *Descent into Hell*, with a cruciform staff from which a standard is flying, while Mary Magdalene catches the eye with her vivid red mantle. The slant of the rocks accompanies and emphasizes the form of her bending body.

Only the Gospel of Luke mentions that Christ, dressed like a pilgrim, appeared to the disciples on their way to Emmaus. Duccio adhered to the Gospel text, reproducing the portrait of an authentic medieval pilgrim: he is distinguished by the knapsack on his shoulder, the pilgrim's staff and the typical wide-brimmed hat. As in the lower scene, the composition is directed towards the right, where there is a village on a hill. An interesting detail is the paved road appearing in two variations: partly with round cobblestones and, below the main gate, with regularly cut stones geometrically laid out.

87

88

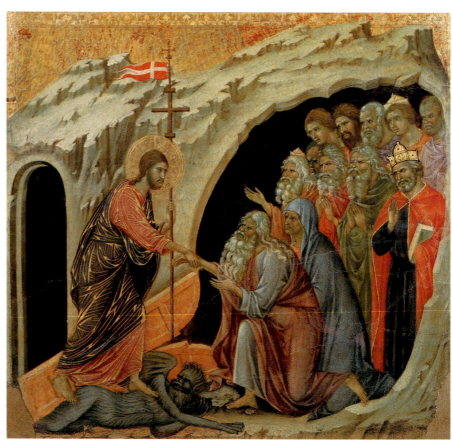

8

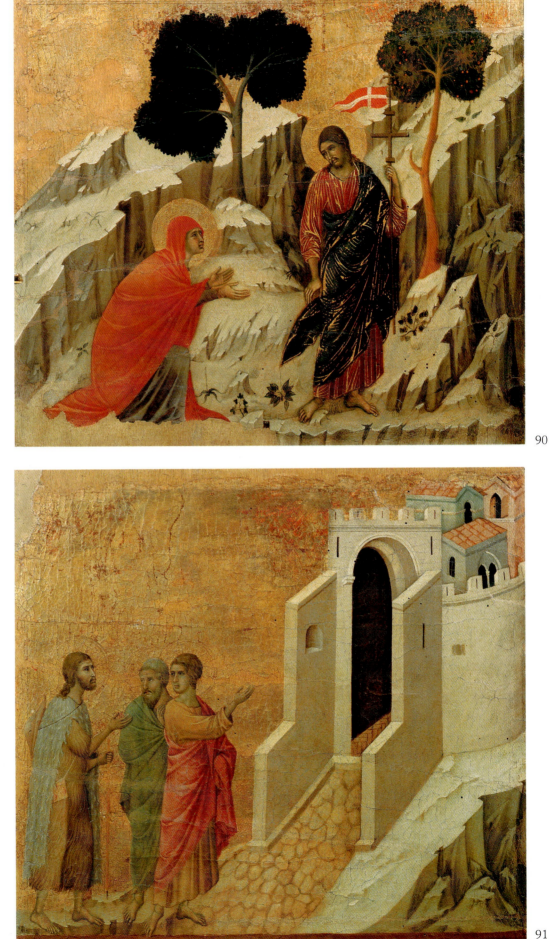

88. Giovanni Pisano
Sibyl
Siena, Museo
dell'Opera del
Duomo

90

90, 91. Appearance
to Mary Magdalene;
Meeting on the
Road to Emmaus
102x57 cm
Siena, Museo
dell'Opera del
Duomo

91

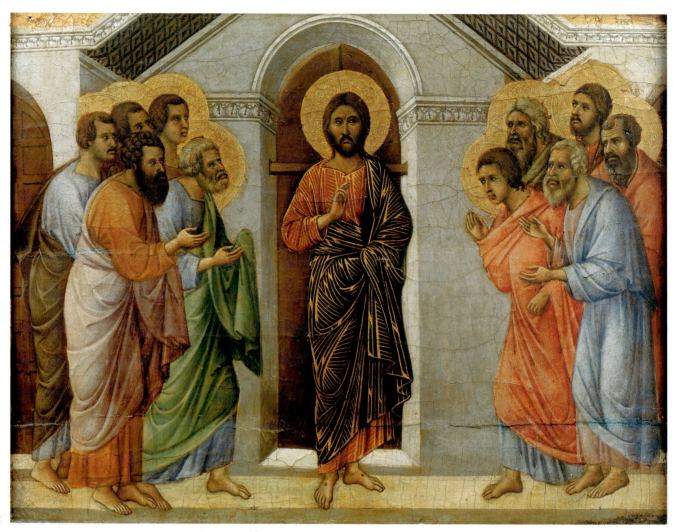

92

Stories of Christ after the Resurrection, back crowning section

The order of the compartments dedicated to the *Stories of Christ after the Resurrection* was probably the following: from the left, the *Appearance behind Locked Doors*; the *Doubting Thomas*; the *Appearance on Lake Tiberias*, the *Appearance on the Mountain in Galilee*; the *Appearance while the Apostles are at Table*; the *Pentecost*. A seventh panel is supposed to have existed in the centre, perhaps containing the *Ascension* and culminating in a representation of *Christ in Glory*. Unfortunately nothing is known of either scene.

APPEARANCE BEHIND LOCKED DOORS; DOUBTING THOMAS

Both episodes take place in the same surroundings, the house where the apostles took refuge for fear of the Jews. The door in the centre, firmly shut with a horizontal bar (a detail which emphasizes the miraculous nature of the event), frames and shows up the dominant figure of Christ, towards whom the two groups of apostles are converging.

The *Doubting Thomas* is the only panel, apart from

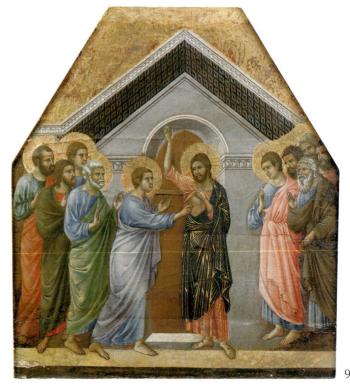

9.

the *Funeral of the Virgin* from the front crowning section, still in its probable original form. The position of Thomas's feet is curious: the right foot is painted as if his legs were crossed under his robe.

APPEARANCE ON LAKE TIBERIAS; APPEARANCE ON THE MOUNTAIN IN GALILEE

In the *Appearance on Lake Tiberias* the vertical position of the figures of Christ and Peter is in opposition to the compact volume of the group of apostles, giving balance and harmony to the spatial distribution. The painting is superior in narrative description to the scene of the *Calling of Peter and Andrew* (very similar in its basic layout), and greater significance is given to the actions of the characters. The two disciples are bending over to lift the heavy catch in a most lifelike pose.

The *Appearance on the Mountain in Galilee* is simpler and barer and descriptive details are deliberately left out: Christ is entrusting the apostles with the task of spreading the faith (the books that two of the disciples are holding are a reminder of preaching) and nothing must distract attention from his words.

92. *Appearance Behind
Locked Doors*
39.5x51.5 cm
*Siena, Museo dell'Opera del
Duomo*

93. *The Doubting Thomas*
55.5x50.5 cm
*Siena, Museo dell'Opera del
Duomo*

94. *Appearance on Lake
Tiberias*
36.5x47.5 cm
*Siena, Museo dell'Opera del
Duomo*

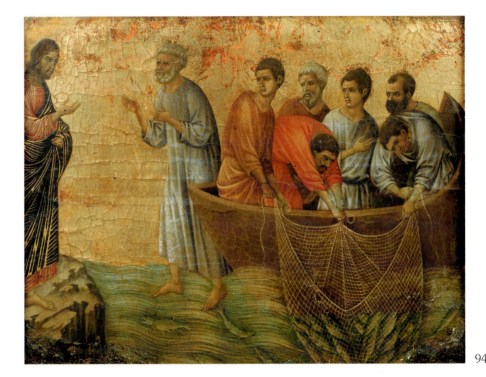

94

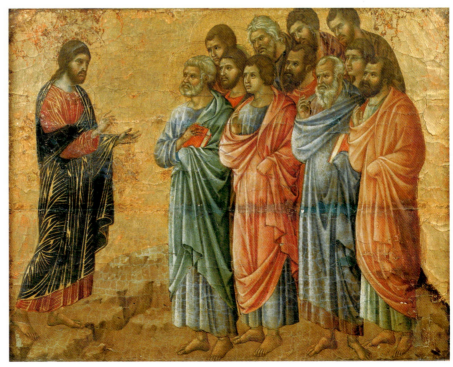

95. *Appearance on the
Mountain in Galilee*
36.5x47.5 cm
*Siena, Museo dell'Opera del
Duomo*

95

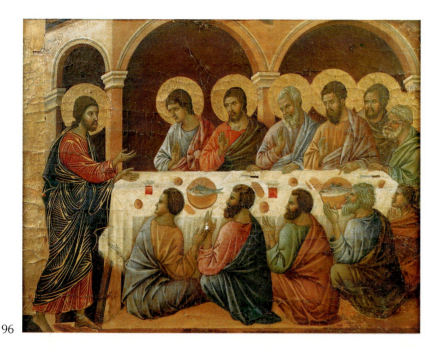

*96. Appearance While the Apostles
are at Table
39.5x51.5 cm
Siena, Museo dell'Opera del Duomo*

96

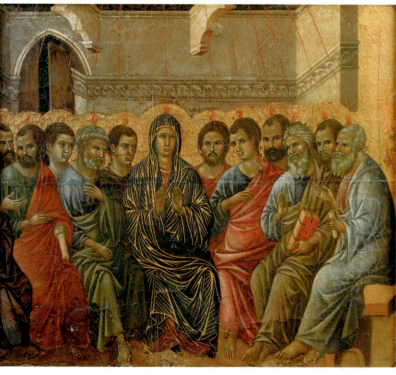

*97. Pentecost
37.5x42.5 cm
Siena, Museo dell'Opera del Duomo*

97

APPEARANCE WHILE THE APOSTLES ARE AT TABLE;
PENTECOST

Rather than referring to the episode told by Mark (in which Christ reproaches the eleven for not believing those who said they had seen him after his death), the *Appearance at Table* alludes to the story in Luke, where Jesus appears before the disciples and, to dispel all their doubts, eats with them. The detail of the fish painted on the plates repeats the gospel text to the letter.

In the *Pentecost* Duccio goes back to traditional iconographic schemes and includes the Virgin, of whom no mention is made in the Acts of the Apostles,

the source of the episode. Mary's entire figure, illuminated by the highlights of her robe, becomes a form with strongly curved outlines contrasting with the loose drapery of the disciples' garments. The succession of haloes echoes the group in a shining golden frame, on which twelve tongues of flame are burning — the symbol of the descent of the Holy Spirit. The panel has obviously been cut on the left side, where the twelfth apostle is missing; only the red ray descending from above remains.

The Last Days of the Virgin, front crowning section

Various conjectures have been made to establish both the number of panels and their original layout: they were probably seven (six are remaining) and the missing part, from the centre, was probably an *Assumption of the Virgin*, with the Budapest *Coronation* above it. The stories of the Virgin, drawn mainly from the *Legenda Aurea* by Jacob di Varagine, are in the following order: from the left, the *Announcement of Death*, the *Parting from St John*, the *Parting from the Apostles*, the *Death (Dormitio Virginis)*, the *Funeral*, the *Burial*.

ANNOUNCEMENT OF DEATH; PARTING FROM ST JOHN
In the simple architectural frame enclosing the scenes space is articulated with effortless accuracy. The beamed ceiling, the linearity of the horizontal pattern on the back wall, the slender arches opening onto the room where Mary is sitting, lend calm elegance to the surroundings. In the *Announcement of Death* the angel, his robe light and fluttering, offers the palm branch to the Virgin — the *palma mortis* is present in all the episodes as an emblem of death and a symbol of paradise to come. The gesture of affection and intimacy between Mary and John, the favourite apostle to whom Christ on the point of death entrusted his mother, gives an atmosphere of tenderness to the next scene. Outside the room the disciples are present at a more restrained embrace between Peter and Paul (included in the stories of the Virgin according to a tradition handed down by a few of the literary sources).

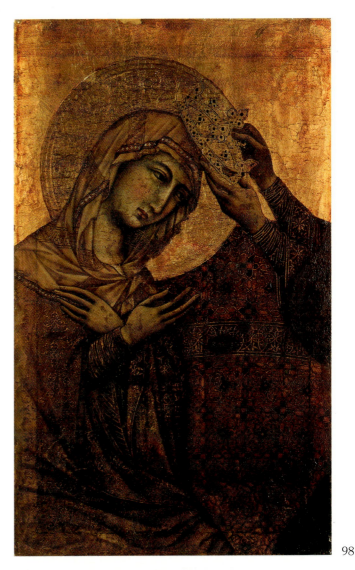

98

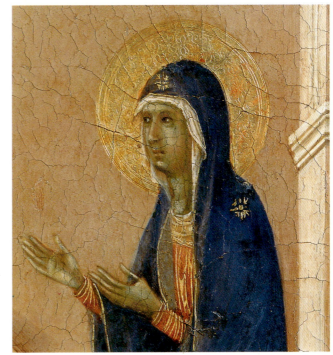

99

98. *Coronation of the Virgin*
51.5x32 cm
Budapest, Szépmüveszéti Muzeum

99. *Announcement of Death, detail*
Siena, Museo dell'Opera del Duomo

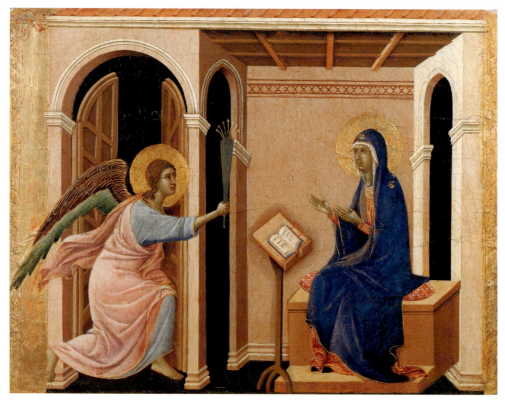

100

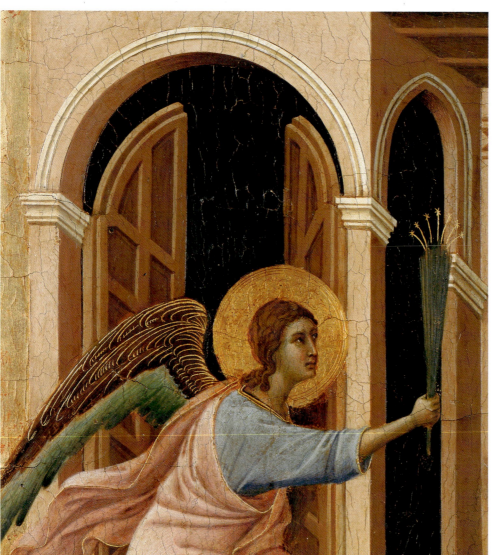

101

*102, 103. Parting from
St John, and detail
41.5x54 cm
Siena, Museo dell'Opera
del Duomo*

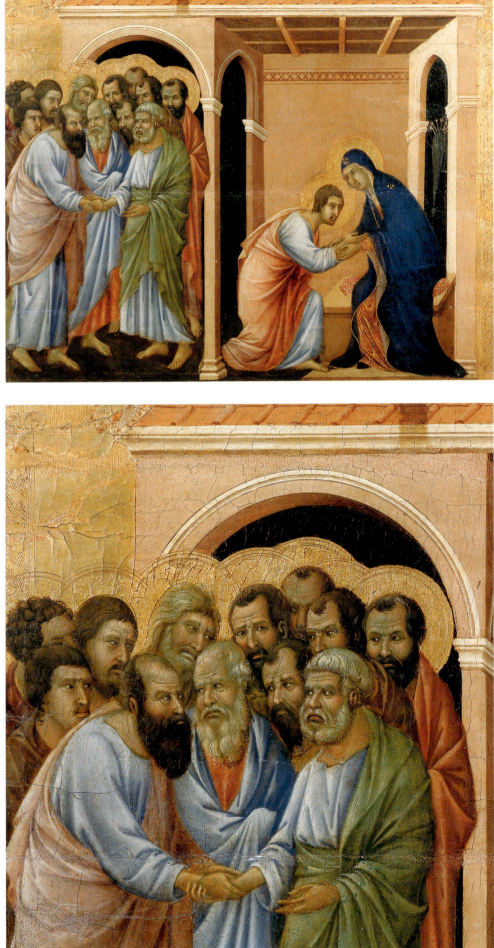

102

103

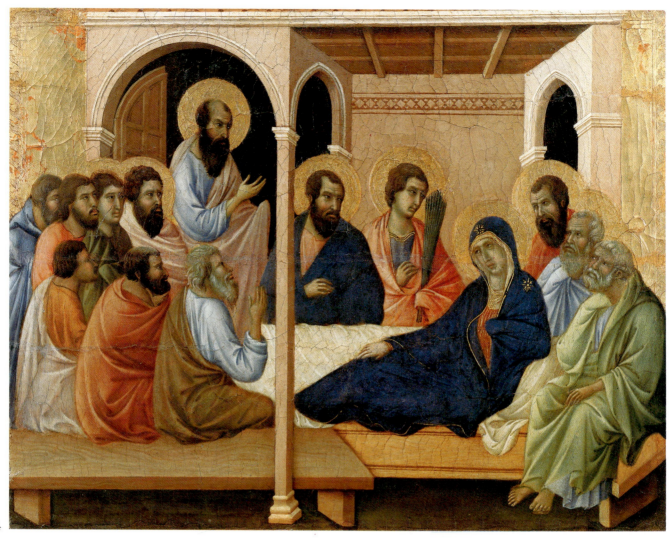

104

PARTING FROM THE APOSTLES; DEATH (DORMITIO VIRGINIS)

In the *Parting from the Apostles* the spatial element is harmoniously articulated by the slender pillar in the foreground which, respecting the distribution of characters, divides the room into two. The prominent figure of the standing apostle, identified as Paul, is clearly outlined against the dark space formed by the open door, balancing the horizontal image of Mary.

The moving scene of the *Death* shows a traditional approach drawn from Byzantine models, combined with freshness of composition. A multitude of haloed figures, orderly and dignified, recall the solemn court of heaven in the prospect. Only the apostles in the foreground, Peter and John, are portrayed in more spontaneous attitudes, while Christ holds up the *animula*, the soul of Mary who has just died.

10

104. *Parting
from the Apostles
41.5x54
Siena, Museo
dell'Opera del
Duomo*

105, 106. *Death
of the Virgin, and
detail
40x45.5 cm
Siena, Museo
dell'Opera del
Duomo*

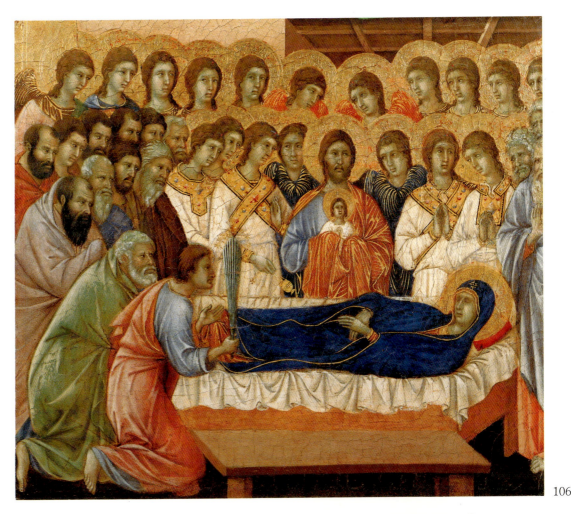

106

FUNERAL; BURIAL

The apostles, led by John with the palm, are carrying
the bier on which the body of the Virgin is laid. At the
same time a Jew attempts to desecrate it and is struck
by sudden paralysis; this is caused by the movement
of Peter who turns round in anger, disturbed by the
sacrilegious gesture. The polygonal building of white
marble already seen in the *Entry into Jerusalem* ap-
pears again, enclosed by battlemented walls against
which the shining gold circles of the haloes stand out.

In the following scene the background of deeply in-
dented rocks with small leafy trees evokes the valley
of Jehoshaphat where the burial took place. The disci-
ples, grouped quietly round the tomb in attitudes of
tender affection, show their heartfelt participation in
the sad event, particularly the person on the left who
is lifting his hand to his mouth in grief.

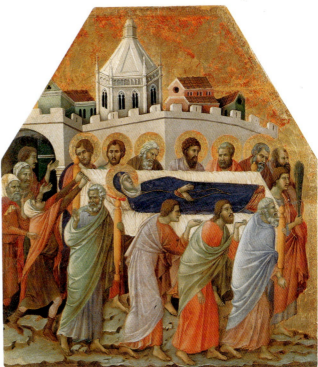

107

107. *Funeral
58x52.5 cm
Siena, Museo dell'Opera del Duomo*

108. Funeral, detail
Siena, Museo dell'Opera del Duomo

109. Burial
41x54.5 cm
Siena, Museo dell'Opera del Duomo

108

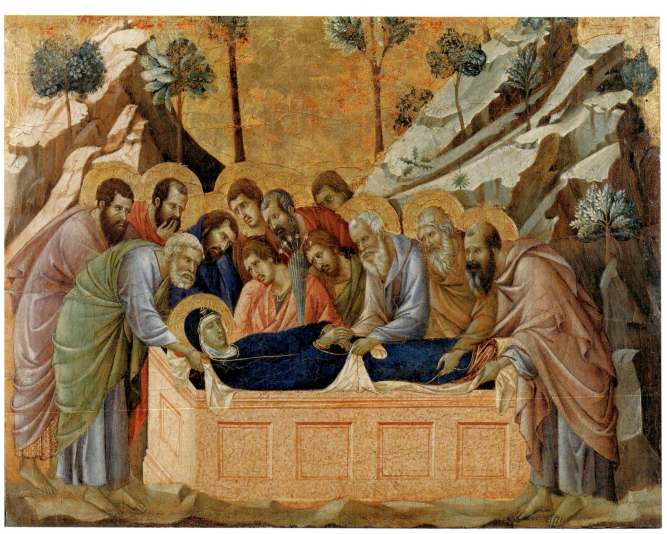

109

The Last Years

No reliable information exists on Duccio's artistic output during the years which elapsed from the completion of the *Maestà* up till his death some time between the end of 1318 and the first half of 1319. During recent restoration work (1979-80) in the Sala del Mappamondo of the Palazzo Pubblico in Siena, a new fresco was discovered below the imposing *Guidoriccio da Fogliano*, representing a castle on a hill and two people in the foreground. The attempt to discover the identity of the unknown author of this work has given rise to much controversy among critics. Max Seidel and Luciano Bellosi are in favour of Duccio, Brandi prefers Pietro Lorenzetti, Carli opts for Memmo di Filippuccio, Chiara Frugoni and Federico Zeri suggest Simone Martini (denying his authorship of the *Guidoriccio*). However, Duccio is known principally as a painter of panels and the problem remains unsolved. The fresco, of outstanding executive quality both in the skilful choice of descriptive detail and in its overall coherence, was badly damaged by the *Mappamondo*, a large, revolving, circular painting by Ambrogio Lorenzetti, which was placed on top of it in 1345.

The *Polyptych no. 47*, originally in the Hospital of Santa Maria della Scala and now in the Pinacoteca of Siena, is less problematic. Only the central part of the work is of indisputable Duccio authorship; the remaining panels are ascribed to an able, but as yet unknown, assistant. The poor condition of the panel with the Virgin and Child has reduced both its attractiveness and the possibility of more thorough research on it. However the superb monumentality of the half-length figures and the tender embrace of the mother and son reveal the undeniable presence of Duccio.

The unusual posture of the legs of the Infant Jesus reappears here, a repetition of a solution already achieved in earlier Madonnas (from the *Crevole Madonna* to the *Stoclet Madonna*).

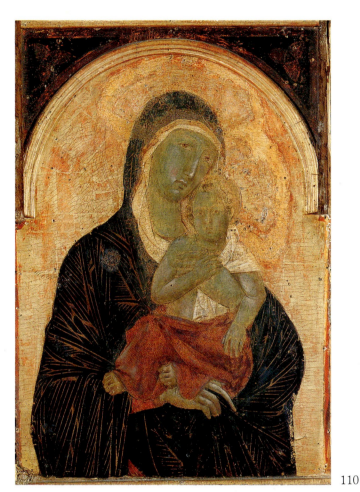

110

1

110. Polyptych no. 47
*Detail of the Madonna
and Child
Siena, Pinacoteca*

111. *Fresco discovered
below the Guidoriccio
da Foligno
Siena, Palazzo Pubblico*

Short Bibliography

G. DELLA VALLE, *Lettere Sanesi*, Rome 1785.

G. MILANESI, *Documenti per la storia dell'arte senese*, Siena 1854-55.

E. CARLI, *Vetrata duccesca*, Florence 1946.

R. LONGHI, *Giudizio sul Duecento*, in "Proporzioni", II, 1948, pp. 5-54.

C. BRANDI, *Duccio*, Florence 1951.

C. VOLPE, *Preistoria di Duccio*, in "Paragone", 49, 1954, pp. 4-22.

F. BOLOGNA, *Ciò che resta di un capolavoro giovanile di Duccio. Nuovi studi sulla formazione del maestro*, in "Paragone", 125, 1960, pp. 3-31.

F. BOLOGNA, *La pittura italiana delle origini*, Rome 1962.

C.G. ARGAN, *Storia dell'arte italiana*, Florence 1968.

E. CARLI, *La Maestà di Duccio di Buoninsegna*, Siena 1969.

C. VOLPE, *La formazione di Giotto nella cultura di Assisi*, in *Giotto e i giotteschi ad Assisi*, edited by G. Palumbo, Rome 1970, pp. 15-59.

G. CATTANEO, E. BACCHESCHI, *L'opera completa di Duccio*, Milan 1972.

P. TORRITI, *La Pinacoteca Nazionale di Siena. I dipinti dal XII al XIV secolo*, Genua 1977.

S. SETTIS, *Iconografia dell'arte italiana, 1100-1500: una linea*, in *Storia dell'arte italiana*, III, Turin 1979.

J. H. STUBBLEBINE, *Duccio di Buoninsegna and His School*, Princeton 1979.

J. WHITE, *Duccio: Tuscan Art and Medieval Workshop*, London 1979.

E. CARLI, *La pittura senese del Trecento*, Venice 1981.

AA.VV., *Il Gotico a Siena*, exhibition catalogue, Florence 1982.

L. BELLOSI, *"Castrum pingatur in Palatio" 2. Duccio e Simone Martini pittori di castelli senesi "a l'esempio di come erano"*, in "Prospettiva", 28, 1982, pp. 41-65.

M. SEIDEL, *"Castrum pingatur in Palatio" 1. Ricerche storiche e iconografiche sui castelli dipinti nel Palazzo Pubblico di Siena*, in "Prospettiva", 28, 1982, pp. 17-40.

F. BOLOGNA, *The Crowning Disc of a Trecento 'Crucifixion' and other Points Relevant to Duccio's Relationship to Cimabue*, in "The Burlington Magazine", CXXXV, 1983, pp. 330-340.

F. DEUCHLER, *Duccio*, Milan 1984.

L. BELLOSI, *La pecora di Giotto*, Turin 1985.

G. RAGIONIERI, *Simone o non Simone*, Florence 1985.